PICTURES UNDER DISCUSSION

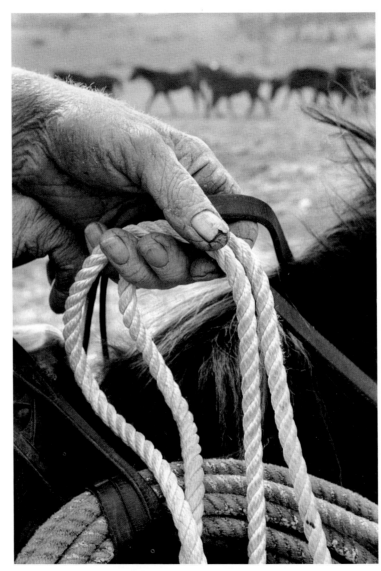

COWBOY WHISTLE MILLS, 1970

PICTURES UNDER DISCUSSION

JOHN LOENGARD

A BOB ADELMAN BOOK

AMPHOTO
an imprint of Watson-Guptill Publications/New York

To Charles, Jennifer, and Anna

My thanks to the technicians of *Life*'s black-and-white lab, who have developed my film with care and attention for thirty years; to Bob Adelman, who had the generosity to suggest this book and the skill to produce it; to Jill Gill, who put the pictures in this book in order and gave much other good advice; to John Downey, Peter Christopoulos, Hans Kohl, Carmine Ercolano, George Karas, and Herb Orth, the present and past chiefs of the black-and-white lab, who have let me print my pictures there as easily as if it were my own darkroom; to Glorya Hale and Marisa Bulzone who have added their expert editorial advice to their enthusiasm; and to Elizabeth Kalkhurst, whose help and encouragement has been essential to this project, as well as for her delight in carrying a tripod on assignment.

Library of Congress Cataloging-in-Publication Data

Loengard, John.
 Pictures under discussion.

 Includes index.
 1. Photography, Journalistic. 2. Loengard, John.
I. Title.
TR820.L56 1987 770'.92'4 86-32096
ISBN 0-8174-5539-6
ISBN 0-8174-5540-X (pbk.)

Design: Jay Anning
Design Consultant: Bob Ciano
Editorial assistance: Susan Hall
Production: Dayna Burnett
Typography: U.S. Lithograph
Printing: Dai Nippon Printing Co.

I took my first picture when I was eleven and the first one I thought was very good when I was fifteen. That same year I learned I could imagine how a picture might look and then go out and arrange it, but it was not until I was seventeen that I knew exactly how a picture would look when I took it.

I thought photography was magic; I could catch a picture in a box and make copies of it forever. I was on the staff of my high school newspaper, where we worked quickly and what I photographed on Wednesday was public Saturday. What's more, the newspaper gave me an excuse to take pictures of what people actually did.

Schools did not teach photography then, and when I entered Harvard it seemed valueless to the faculty except to copy paintings. I took photography as my own subject and worked at it harder than I did my college courses.

During my freshman year, Henri Cartier-Bresson published his book of pictures called *The Decisive Moment* and quickly became the idol of most young journalist-photographers. His "moment" came when his eye fixed the passing subject into a composition, and the subject's motion, frozen in this pattern by the shutter, took on the look of a specific act—a moment. He posed nothing, so for a long time, neither did I.

I did quite well, but soon I began to notice the frame or two at the beginning of each roll of film—the ones that must be shot off to be sure the film is properly loaded. My camera had a knob to wind the film. I gripped it in one hand and twisted the camera with the other, releasing the shutter each time—thus snapping my shoe, the wall, or half a dog. They were bad pictures but they showed unexpected and sometimes satisfying relationships. I questioned the ideas of composition handed down from painting and looked for new ones I thought more photographic. Remember, I was a sophomore.

Soon I found myself taking two kinds of pictures. On the one hand, I was a young photographer looking for chance compositions and the truth that seemed to lie in them. On the other, I was still a young journalist who was happy to arrange, cajole, and confront any subject (I would have threatened one, but I never got the chance) in order to turn a story into pictures or bring a point into focus.

These two approaches to photography did not blend for a long, long time. During three years in the Army, during three years freelancing for *Life* magazine, during my first three years on *Life*'s staff, I was still not doing what I wanted to do. For *Life* I often directed my subjects into poses that would produce a feeling of depth, which helped to dramatize them. Since I was good at relating a subject in the foreground to what was in the background, this was easy for me to do, but it was opposite from the flat, abstract look of the accidental "wind-ons" that I felt were better photographs. I wanted to mix the two—to make flat pictures that had depth; to find a picture by chance, yet have some control over it.

Suddenly, I succeeded on a beach in Rio where I had gone to cover a quiet coup by some generals. I was seated in a café with nothing to do on a cloudy day when a lone middle-aged man came walking along the shore in my direction and—very unusual for me—I walked over to photograph him.

The scene in the camera was a little corny. It was not dramatic; it was not news. But it felt very, very clear, as if everything related to one point. When I saw a print in New York, I said

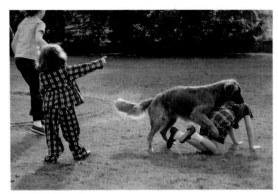

WATSON CHILDREN, 1957
"I was looking for chance compositions..."

to myself (we've never spoken like this before or since), "That's your style!" Surprisingly it was. This book started on that day.

The style is not something I can impose on a subject. I merely look for a point from which the camera can most vividly record the illusion of depth and from there I try to organize the picture (still keeping the background as important as the foreground) so objects in the photograph also relate to each other through the play of their abstract shapes on the surface of the print. I found I could duplicate the effect and explore it and have done so for twenty years.

My transition from student photographer to *Life* photographer was remarkably easy. *Life* was twenty years old in 1956 (the year I graduated from college) and was looking for young photographers. That year Bruce Davidson, Ken Heyman, myself, and two others were given fairly regular assignments. I was very proud to be taking pictures for *Life*. The *Life* photographer was still a minor celebrity and *Life's* name opened doors and gained extraordinary cooperation, which it continues to do today. There was a glamour to working for *Life*, even doing the small assignments I was given. However, while photographers like Margaret Bourke-White thrived on this public role, the trend in the mid-1950s was toward a more private kind of photography.

When *Life's* Picture Editor, Ray Mackland, took us tyros to lunch in 1957, we perplexed him by saying that the photographers we admired most were Cartier-Bresson, W. Eugene Smith, Ernst Haas, and Robert Frank— all of whom were working irregularly for the magazine at the time—and only one staff member, Leonard McCombe. "How about Alfred Eisenstaedt?" Mackland asked. "Gee, he's the one I admire. He can go out and do any story." Actually we did admire Eisie, but differently. He proved that a photographer could maintain his independence while working in an organization and establish his reputation without standing apart from his colleagues as a "star." His example was one I hoped to follow in my own way, but his work, like Bourke-White's, seemed at the time to be less expressive than that of the photographers we named, who mixed their feelings with their reportage in strong, new ways.

I was the only member of the group to join *Life's* staff, maybe because to me a staff job seemed ideal. Others felt there was more freedom in freelancing, but to me it seemed better to face one editor than a dozen. I felt I could be quirkier when my pictures did not have to sell in London, Paris, Rome, and Tokyo, as well as to five different editors in New York.

I did not feel fettered by an organization, which is not to say it is always easy to be part of one. In 1965, a year after my day in Rio, I thought of quitting because steady news assignments in South Vietnam, Ethiopia, and England, although glamorous, did not give me the time or opportunity to photograph as I wanted. I refused to do more news stories, and my refusal resulted in an assignment to photograph Louis Armstrong, the jazz musician. The story changed the way I worked within the system at *Life*.

It began with a tour of Europe. I worked for the first time without the usual *Life* reporter, and I loved it. *Life* reporters could be wonderful, imaginative, enthusiastic, picture-minded, and good company, but they could also be something of a barrier between myself and the person I was photographing. Their job was to ask questions, take notes, and arrange what the photographer needed. Too often I felt I was swaddled in a journalistic cocoon. When I returned from Europe, a sincere young man was assigned to go with me to Armstrong's house in Queens. Halfway through the afternoon he called Armstrong an "Uncle Tom." We both were thrown out. In the cab going back to Manhattan I swore that I'd work alone in the future.

My second innovation was simple: I

wanted to print my own pictures because there is a strong sense of light and shadow in my work and many technicians flatten that contrast out. I joined Gjon Mili as the only photographers allowed to use *Life's* dark-rooms. I also began to take part in the layout of my stories, something few *Life* photographers were comfortable doing. Although I may be too close to my pictures to be objective, I'm certain which are best, and have ideas about which ones should start an essay, which end it, and what photographs work best together to tell the story. (I've benefitted from a series of *Life's* Art Directors from Bernard Quint to Bob Ciano who have listened a bit—but not too much—and then gone and transferred my pictures to the page with their own sensitivity and vigor.)

My new way of working put me somewhat outside *Life's* system. I was not interested in producing the most covers, the most stories, or the longest essays, and it says a lot for the magazine that no one minded. I produced a series of stories on subjects ranging from the painter Georgia O'Keeffe to a crime-ridden apartment house in New York City to my own family's summer house in Maine.

Without a news element my stories sometimes took a long time to get in print. Six months was normal, and a year and a half not unheard of (eight years was the record for me).. For a weekly magazine, things could move surprisingly slowly. Finally, I had to convince myself that every story I worked on would some day run successfully and move on to the next story, which I'd try to make even better. I gave myself a standard (I think it was

75 percent) that would be an acceptable percentage of my work to get into print. If it fell below that, I told myself, I should leave. It was often nip and tuck, but I never had to face that decision again.

Working alone on stories, I began to feel the anonymity of motels on interstate highways reached by jet planes and rental cars. It was hard to have a good time, and the only way I could make the loneliness excusable was by taking pictures I thought were very good, even valuable.

Pictures are taken quickly and as a photographer I never knew what to do in my spare time. Even at twenty-one I planned to be an editor as well as a photographer at thirty-five, and in 1969 I began sitting in for *Life's* Picture Editor when he was on vacation. I enjoyed putting my experience to work in areas beyond my own photography. When *Life* stopped weekly publication in 1972 I became a picture editor full time, first on the special reports of *Life* and five years later, on the monthly. I don't need to take pictures every day to be happy, and if anything I bring more intensity to photographing now when it is a special treat, than I did when it was my only job.

Actually there are two kinds of photographs: mine and other people's. I never think of what I might do myself when I look at someone else's pictures. I never wish I could do the assignments I give others because there is no subject in the world I have ever wanted to photograph. It's the picture, not the object, that is important to me. When I have a general itch to take pictures and don't have an assignment, I will take pictures of people I

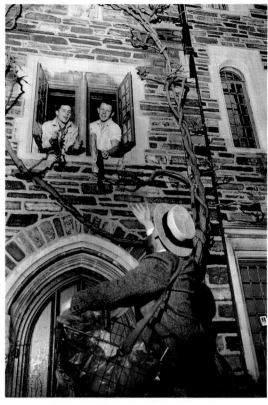

PRINCETON UNIVERSITY, 1957
"I was good at relating the foreground to the background...... "

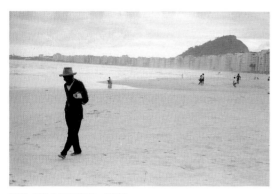

RIO DE JANEIRO, 1964

"I said to myself, that's your style..."

know around me. One out of ten of the pictures in this book were taken that way.

My job as Picture Editor is to ask the right photographer to take the right picture at the right time and then tell others what I think should be done with results. Judgment comes into play anticipating what a subject will actually be like because given that, you can anticipate what a photographer might do. Will things be rushed? Will there be action or is the subject static? Is the subject subtle and hard to isolate or is it so common it is difficult to see it freshly? Should the story be photographed candidly, semi-candidly, or should it be posed? Should the pictures be in black and white or color?

I can't tell you how many photographers have done significant work that has appeared in *Life* over the last fifty years, but if I wanted to invite them to get together I'd order at least one hundred and fifty chairs. Those before me led the world to appreciate the photographer who is a journalist and made it easier for later arrivals like myself to practice the trade. I thank them all.

The truth is I never read *Life* magazine when I was growing up. My mother's mother once talked about remarkable pictures taken on the Russian front, but they were small and looked dull to me—tiny figures in white uniforms in the snow. Even at sixteen, when a cousin showed me the dramatic and moving set of pictures in *Life* of a village in Spain taken by W. Eugene Smith, I was not impressed, but six months later Alfred Eisenstaedt, while covering a primary in New Hampshire, photographed my school headmaster. When I saw his sharp, well-composed, candid pictures of someone I knew, it was thrilling. I became interested in what *Life* photographers did.

I began to read the magazine, but in a special way. The stories were not important to me without the extraordinary photographs, and if the pictures in a story were merely good, the story did not count for me at all. I guess that explains why when I began my career and *Life*'s Picture Editor told me I did not seem to show a serious attitude toward my assignments, I could not bring myself to explain to him that, actually, I was much too serious. I still am.

There are photographers who produce wonderful looking photographs only for the gallery wall. I never had that urge and sometimes when I see their work I think they confuse photography with painting and give too great a priority to pleasing the eye. The fact is that the camera is literal if anything, which gives it something in common with a thermometer. We believe recordings of both instruments, and we should. Often the tension that exists between the pictorial content of a photograph and its record of reality is the picture's true beauty.

While working as a journalist, I may dream of the perfect picture story, with every photograph a model of my style, but I have never produced one. Sometimes the photographs I like best are not needed to tell the story at hand, so almost half the pictures in this book have not been published before.

I think this is fine. I thought these photographs would belong together eventually. Their order here is the same as in a slide show I use when I'm teaching, where the pictures are arranged according to their various pictorial values. The writing in this book started with a discussion of those slides, and I hope it keeps the flavor of a soft voice mumbling in the back of the room while everyone looks at the pictures.

Let me add my hope that the text will give others a sense of what goes on in one photographer's head. Like doctors, photographers work with what is present. I suspect our chief emotions are anticipation, frustration, and patience, balanced by a marvelous sense of elation when things go right—when we think we've captured within a photograph some missing feeling, some sense of beauty, or bit of mystery in the fabric of life.

PICTURES UNDER DISCUSSION

HENRY MOORE'S *SHEEP PIECE*, 1983

Even before we left New York I was certain there'd be a good picture of sheep wandering around the sculpture on Henry Moore's property. Every book about him printed one, though none seemed to be taken in the dead of winter. It was also clear from these books that Moore was not a relaxed or willing subject.

The moment we arrived he suggested that we take a tour of the estate. Mindful of what I've read about sensitive photographers who, when faced with difficult subjects, keep their cameras out of sight until a rapport develops, I thought of leaving mine in the main house. Luckily, I didn't. We crammed into a little car and careened a hundred yards to the studios. Twenty minutes later Moore turned and said, "That's it." Half the pictures for the story had been taken, but the next half were subject to intense negotiation.

Late the next afternoon I got a grudging five minutes. As I returned to the main building it started to snow. I was glum. "Snow's pretty," said Todd Brewster, the *Life* writer who had arranged our visit. "Can you take pictures of the sculpture in it?" "Too dark," I answered grouchily. I don't like people suggesting what I should photograph, but the question did make me look at the snow. It looked pretty as it began to cling to the branches. "Let's come back at dawn," I said. We'd have light then, and if there was no wind during the night, the snow would have piled high.

At a quarter to seven the fields were pristine, but the sheep were on the far side. I tried moving the flock, but they ran away. "Would you try?" I asked Todd. Was it his Indiana upbringing? His musical talents? I'm sure it wasn't an odor. Who knows? The flock followed him across the field and clustered lovingly around him as he stood behind the *Sheep Piece*.

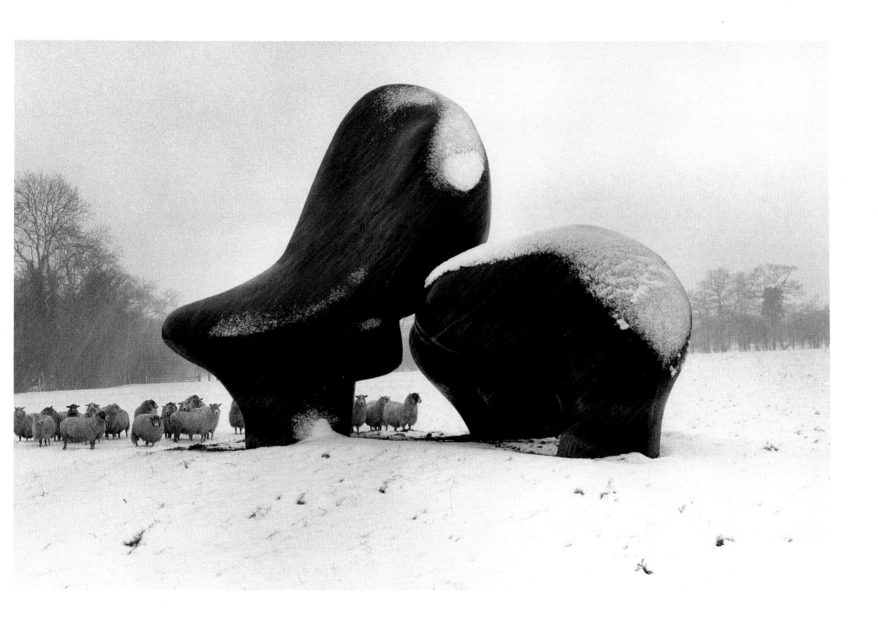

CLOUD IN NOVA SCOTIA, 1979

Photographic film is very high in contrast. What is a shadow to the eye may be a black void on film. It is as if film holds only an ounce of light while the eye holds a gallon. However, if scientists find a way to widen film's latitude (its ability to record a range of light), photographers will lose an important dramatic tool.

Outside Sydney, Nova Scotia, the film recorded some detail on the ground, but so faintly that I could easily lose it when making a print (photographic paper has even less latitude than film, so there is always a two step increase in contrast in black-and-white pictures). I made my exposure as if the brightest part of the sky were the middle tone, thus cutting the film's latitude in half. The darkest parts of the scene dropped out of the picture and those remaining were isolated and dramatized.

It is crucial that the driver had his headlights on. They force you to notice the car and confirm that the day was exceptionally dark. The car seems to be in motion because it is on a road, and we know the cloud is in motion because clouds always are; so there is a sense of movement in the scene, but the picture depends on the tension between the whale of a cloud and the two tiny dots of headlights. If you don't think so, just cover the dots.

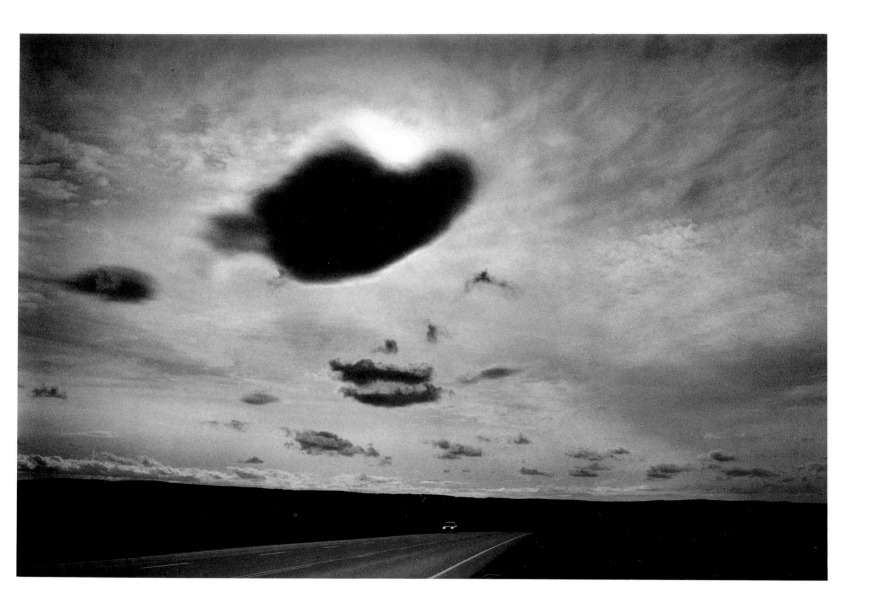

BRIGHTON, ENGLAND, 1968

I suspect that 15,000 years ago when the painter of the animals on the walls of the Lascaux Cave in France finished and stepped back, someone asked, "What is it?" He gave it a caption by answering "Red Deer." That is okay. People feel more comfortable when what they see has a label. In journalism, words as well as pictures convey information, and their tandem use is effective. If I said each pebble in this picture was worth a dollar, the headline could read "Rarest Beach In World!" and our interest in the photograph would change. That's journalism.

However, the facts are that I went to Brighton looking for pictures for a general story on England. Actually, this was the second fully clothed bather I'd found. (The first one was better. He wore a bowler hat and full-length overcoat and looked like a proper English gent, but he lay at right angles to the man here, so I couldn't show his face with the sea behind.) I had to wait for passersby to complete the picture. They add normalcy and motion. They give a sense of place and keep the line of the beach from splitting the picture in two. I tried taking pictures without them, but they're not as good.

Let's say the headline read "Seconds Before Tidal Wave!" This photograph would be no better, but it might be famous. (I also might be dead.) Even so, the bond between words and pictures breaks in time, and a photograph ends up being judged on its own merits. I'm not concerned when words appear with my pictures. "Tidal Wave" and "Dollar A Pebble!" will fade away in time. What is important is the photograph itself.

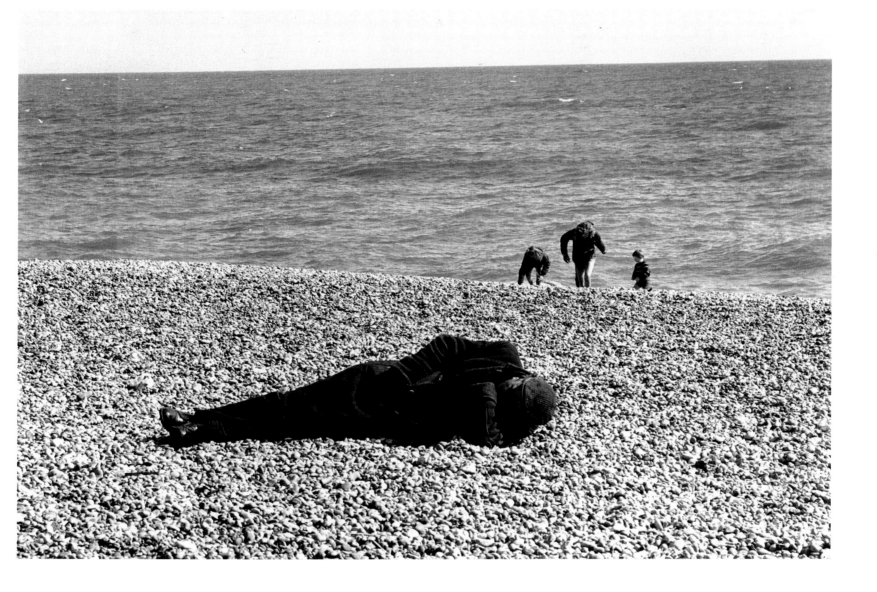

LONG BEACH, CALIFORNIA, 1969

I am astonished when I see photographers measuring light on a sunny day. At President Kennedy's funeral (a sunny day), the White House press photographers were lined up in the driveway, passing the word back and forth that it was "5.6." "Yeah, it's 5.6." "Charlie, it's 5.6." My God, the exposure with the film they were using was f/5.6 every sunny day of their lives.

The point is that there are only about a dozen different exposures you can use in photography. It doesn't take a genius to figure out which one of the twelve possibilities is right—especially on a sunny day.

Sunshine is so constant around the earth that film is sold according to its proper exposure in sunlight. A 400-speed film needs 1/400th of a second in the sun with the lens set at f/16. A 200-speed film needs 1/200th of a second. It's the same wherever the sun shines, even on the moon.

The sun was shining brightly on my third try at making a picture out of the oil derricks, camouflaged to look like apartment towers at Long Beach. I was sure they would make a picture, but I had already tried photographing them alone, and it did not work. They needed to be the focus of a picture but not the subject. I drove down Sunday morning from Los Angeles and these two men and the footprints of many others provided the tapestry into which to weave the towers. Beyond that, it was 1/400th of a second at f/16, just like it said on the film box.

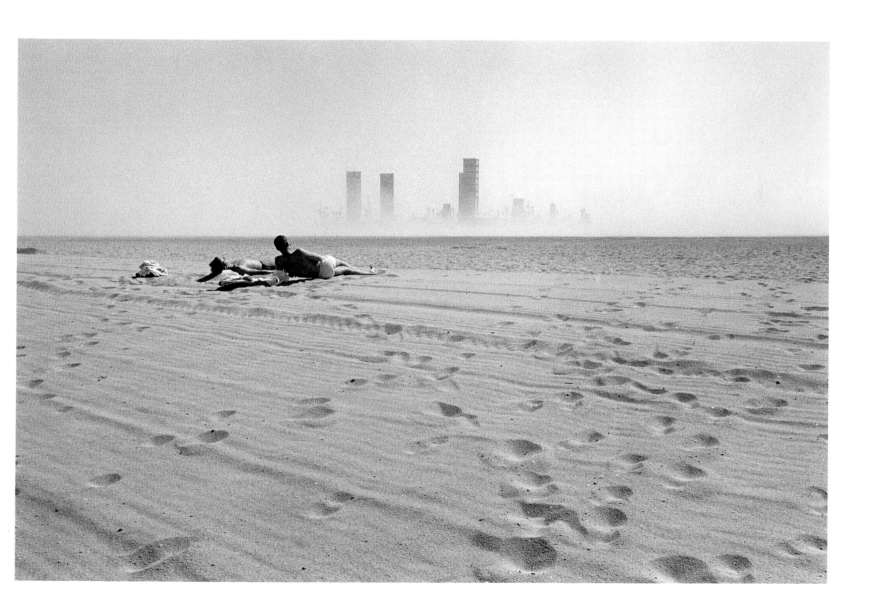

GEORGIA O'KEEFFE AT GHOST RANCH, 1967

I had taken pictures for a story on the painter Georgia O'Keeffe almost a year and a half earlier. For some reason, although the pictures were well-liked at *Life*, no layouts were made. (If you want to make a young photographer with an elderly subject nervous, this is how you do it.) Finally, we made a layout that combined my photographs with copies of O'Keeffe's paintings. Since the story inside the magazine now used the best pictures, the Art Director, Bernard Quint, asked me to go back and take another photograph to combine with a painting for a cover. The photograph could be in black and white, like those in the story, and it could be horizontal.

I was happy to go and see Miss O'Keeffe again, as we had enjoyed each other's company. However, first impressions are vital in photography. Going back meant facing choices I had already made. To avoid that, when I arrived, I suggested that we climb to the one spot at Ghost Ranch we hadn't gone before: the roof.

Miss O'Keeffe sat in front of the chimney and I slumped down across from her. My camera was between my feet and the composition, with a longer than normal lens, was very tight. For the first few frames I centered the chimney and O'Keeffe in the picture. Frankly, I grew a little bored listening to her talk with Dorothy Seiberling, *Life's* Art Editor. Then I got interested in trying to take the most lopsided photograph in history and moved Miss O'Keeffe to the left of the picture, leaving nothing on the right to balance her except empty sky and ground. In the first frames her arms gestured awkwardly, and there was a failing quite common in pictures taken during interviews: the subject's attention was focused elsewhere, on something outside the picture. You wish you knew what it was. Finally though, she seemed at rest, drawn into herself. Actually the body is not relaxed. She's between gesture and response. She's coiled, ready to gesticulate.

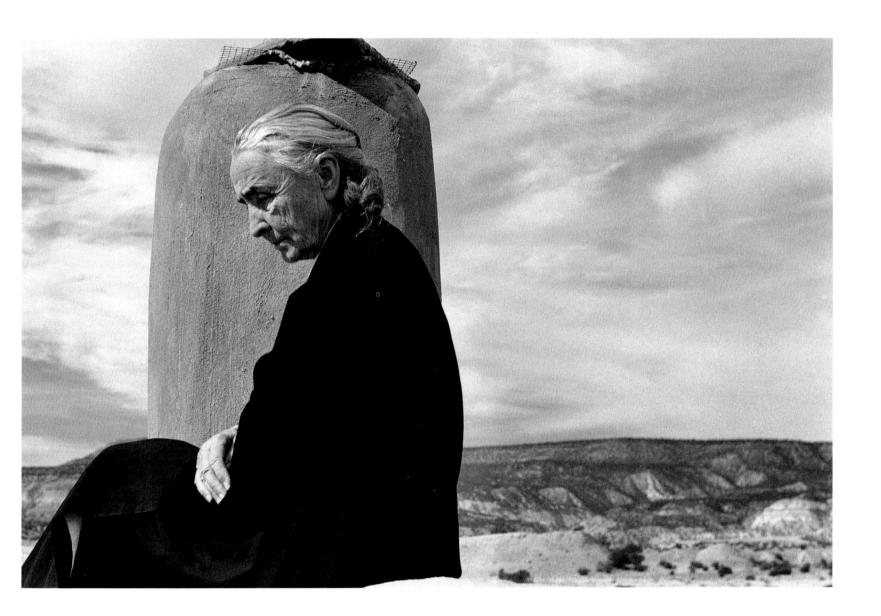

HENRY MOORE'S STUDIO, 1983

I don't like to change a thing in a scene. If I took away the garbage pail lid on the left, I wouldn't take the picture. It's finding things as they are that has magic. It's the texture of small incongruities that is interesting. In a painting it's different, everything is there by choice. In a painting, the lid would be a statement. In a photograph, it's an accident. Of course, I could have purposefully put the lid in the picture. But it's so unimportant, who would bother?

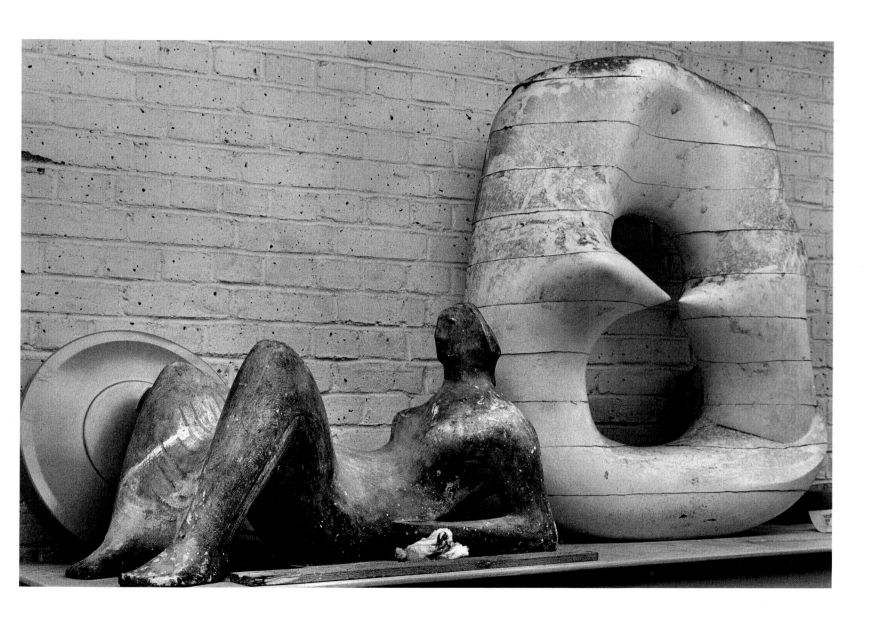

WINDOW OF HENRY MOORE'S STUDIO, 1983

Henry Moore worked on his statues in several studios on his property, shaping them from little clay models in his hand to full-size maquettes ready for the foundry. When a large piece came back he liked to place it in the fields near by so he could see how it looked before shipping a duplicate off to a far-away place, like Deerfield, Illinois.

While waiting on a cold, damp, February afternoon for men to erect a new bronze called *Internal-External Forms*, I noticed in a window the female face with the look of a primeval "smile button" that has become Moore's trademark. It was chance that I was waiting for something to happen and noticed the window, but the more important chance was that this studio had a skylight, which made the room as bright as the outdoors. I could photograph the ivy-covered brick wall outside with the same exposure as the statue inside. It's true, of course, that I could have lit the room if there were no skylight, but then the scene becomes my invention, my decision, not Mr. Moore's. I'm not sure I'd like that.

Why? Although such intervention might increase the photograph's impact or clarity or charm, or drama or motion or excitement, if I tear the fabric of reality the picture becomes the record of a small theatrical production and it's read that way. This is not evil, but it's different from what I intended.

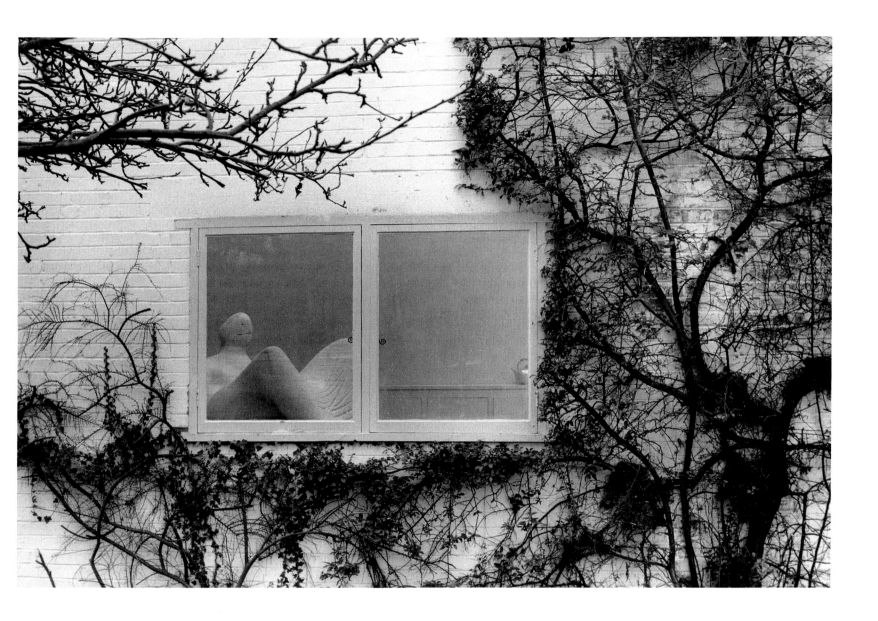

SHAKER FENCE, 1966

When someone asks me to take pictures, my reaction is very negative. I remember all the pictures I have seen of the subject in question and get angry at the thought that someone expects me to take pictures like that. It's only later that it occurs to me that there might be something different I might do. In this case, I remembered all the evenly lit pictures of Shaker buildings and furniture I'd seen. They recorded objects removed from their worldly context, and they were always taken in the shade. Bah!

The last Shakers, all women, lived in two communities in Maine and New Hampshire. The ground floor of the three-story brick building in which the sisters lived at Sabbathday Lake in Maine had large, tinted photographs of stern, bewhiskered elders hanging on the walls. They looked frightening. In the sitting room the sisters watched television in easy chairs bought at Sears, Roebuck & Co. Why? "Well, there have been no brothers to build furniture for many years," the sisters explained, "and it has always been our practice to use the most practical device we can make or buy."

All the first morning I was on my best behavior. I was polite, interested, sympathetic. (Only later did Sister Mildred chide me for being like a camel getting its nose under the tent. "You let him do that—that's all he says he wants—and pretty soon you've got a whole camel in your tent," she remarked as she turned down my request to photograph the television room.)

After lunch I wandered out looking for action. The sunlight on the picket fence across the street was as real as a fist fight. The fence darts off into the woods with the kind of energy that is not often associated with the Shakers. But it has simplicity to it. It also has a certain brutality. Someone coming to shake (dance) in 1850 might have had a glancing, dashing view like this. So long as the sun was shining.

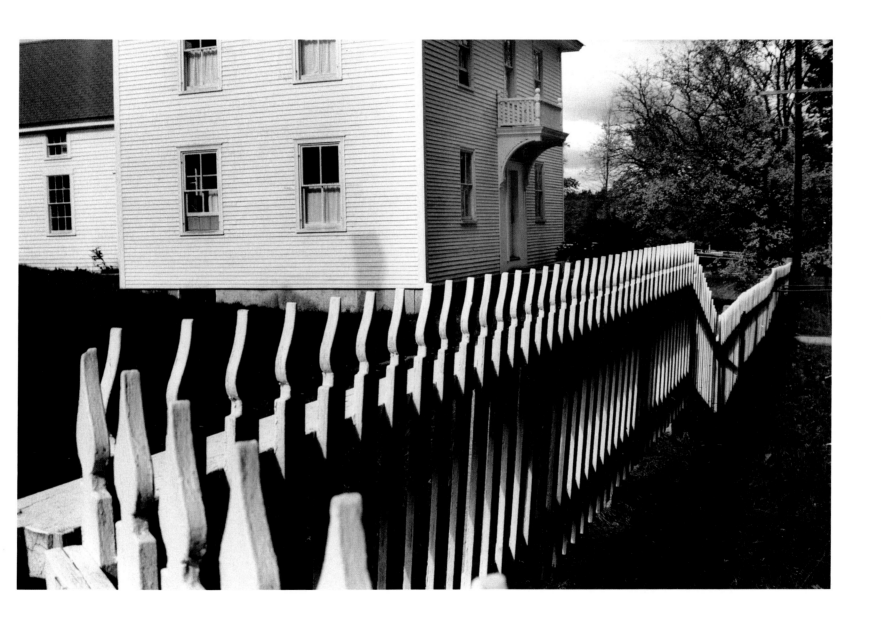

GEORGIA O'KEEFFE AT ABIQUIU, NEW MEXICO, 1966

I took a career classification test when I was twenty to see what I should do as a grown-up. I was asked: "Do you most enjoy (a) going to a baseball game, (b) attending a concert, or (c) going to a museum?" I couldn't decide. I sat there thinking about a ball game on new grass in May, the Friday night rehearsals of the Boston Symphony, and the right hand of one of El Greco's Cardinals. They seemed very similar to me. The test results said I should be a clerk.

Notice that this photograph is as much of shadows as it is of Georgia O'Keeffe. The rows of shadows are of saplings laid across an open patio in her house in Abiquiu, New Mexico. The sandy soil reflects sunlight into her face, reducing the contrast of the scene, making it easy to expose and print.

The previous picture and the one that follows show shadows, too. All three photographs deal with order and progression. The mood of the moment in all is similar, so you can understand the problem I'd have answering another quiz: "Do you like to photograph (a) fences, (b) painters, or (c) jails? I have the same problem when people ask, "Oh, you're a photographer! What kind of pictures do you take?"

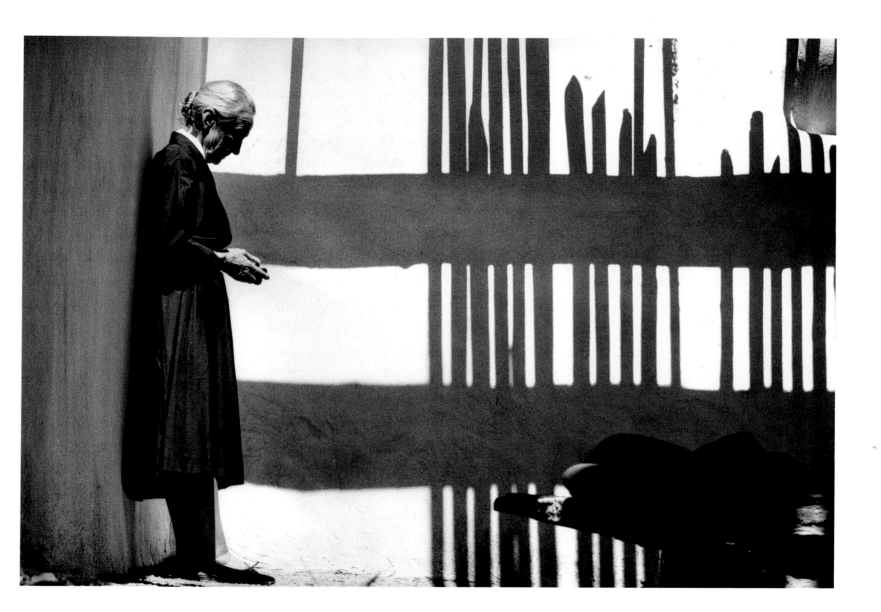

EASTERN PENITENTIARY, 1975

There is sleight of hand in photography. In cards, you try to slip something in without others seeing. In photography, you make the viewer think he's seeing everything while at the same time you make him realize he's not. I try to make my pictures seem reasonable and then, at the last minute, pull the rug from beneath the viewer's feet, very gently so there's a little thrill.

At the unused 150-year-old Eastern Penitentiary in Philadelphia, the caretaker's silhouette increased the sense of depth and clarity in the picture and added scale and human interest to a plain record of a cell block, while the blankness of his figure withholds any accurate sense of his personality.

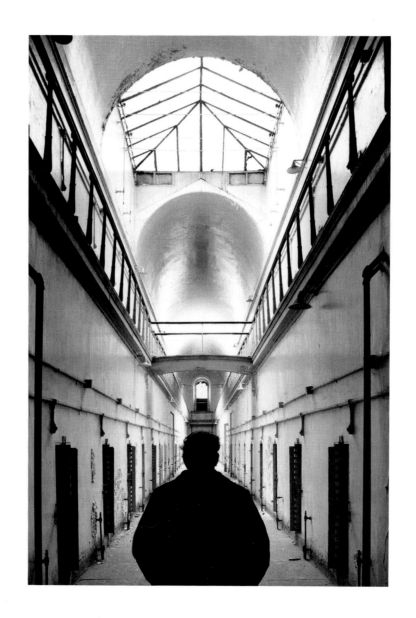

SHAKER BOX, 1966

I've already mentioned that I am the great non-mover of objects, but I moved one here and used the bright sunlight in the room as I might use a spotlight in a studio.

I had already photographed two Shaker inventions, the clothespin and the straight broom. When it came time to try photographing something else, I put this Shaker box on the floor and let the light pour over it, doubling its apparent height, distorting its shape, and generally making me feel as if I'd come upon something I had never seen before.

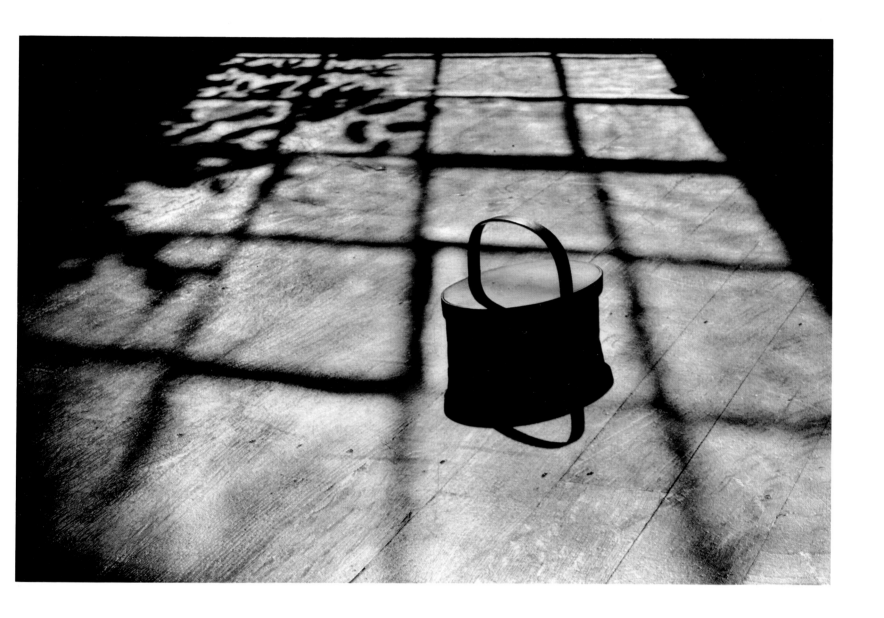

CADET OFFICERS, CANBERRA, AUSTRALIA, 1981

I know I'm boasting, but I believe this is the first photograph of a "right face" ever made. I am proud of my contribution to the list of photographic firsts (it is the only one I have ever claimed), but once it was easier. I discovered photography 107 years after Lois Jacques Mande Daguerre, on a Sunday afternoon when my father mentioned that he planned to buy a camera. The idea that the thing he mentioned could "take pictures" made me leap up and rush to the drugstore on the corner to buy film for the box cameras that were at home. "What size?" the man asked. "Size?" I replied. Who said photography was easy?

In 1969, an astronaut snapped the Earth from his space craft above the moon and made the ultimate photographic first. Photojournalism had thrived in the 1940s and 1950s as advances in film, lighting, and lenses combined to permit photography of most human activities for the first time. The hummingbird in flight and the housewife were documented. Now we can expect that the first pictures of the Second Coming will be thrilling, but aside from that, nearly a century and a half after Daguerre's announcement, there are few virgin sights left for the camera. I'm glad I found my little crumb.

I did not plan it. At Australia's equivalent of West Point, they let me photograph morning formations, which they performed with a lot more snap than I and my fellow draftees had at the *First Loudspeaker & Leaflet Company* in North Carolina. I wanted to get to the heart of their precision, not record their day, so I pulled out a small telephoto lens I rarely use. With it I could isolate the feet of the cadets from a comfortable distance, thankful I was no longer a soldier myself.

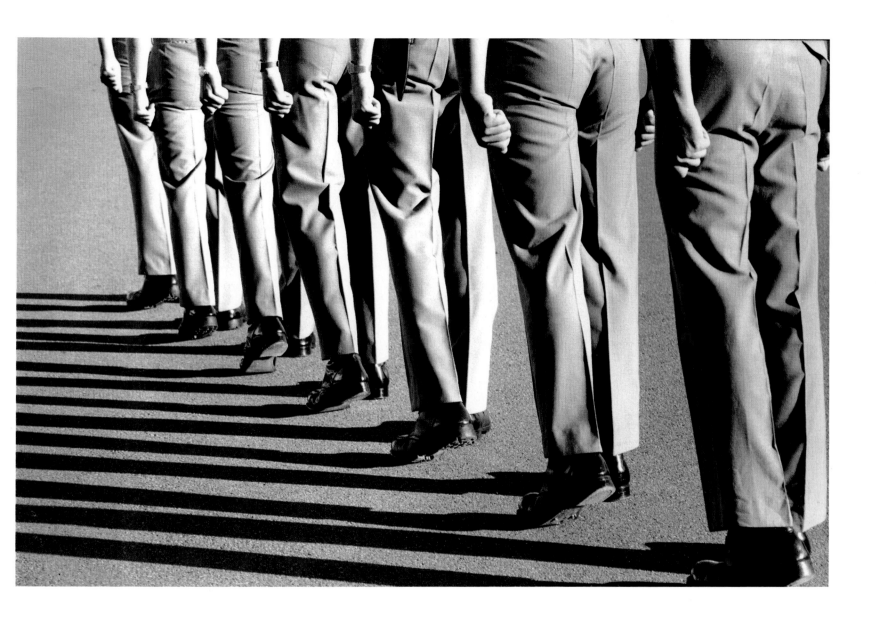

BEER DELIVERY, OTTAWA, CANADA, 1984

When I started taking pictures for *Life* magazine in 1956, people asked for my autograph. In the 1960s, guys from the local TV station started getting the attention. To say, "Mabel, I'm going to be on the news tonight! Channel 7!" was more exciting than "Mabel, I may be in *Life*. They don't know when, but they took my picture!" It was immediate gratification and my turn came in Ottawa in 1983.

The TV station wanted to show one of the one hundred photographers at work on the book *A Day in the Life of Canada* and asked me to come down to the market below the Parliament. A truck delivering beer caught my eye. I flopped down on the pavement, something I usually don't do. I feel I should be able to find pictures without looking for peculiar vantage points. I don't want to say, "Sorry, lady, I can't take your picture. I can't find a ladder." So why did I do it this time?

For one thing, I thought if I did something unusual, I'd have a better chance of getting on the six o'clock news. For another, it helped the picture. It let me hide the market distractions behind cartons of beer and the low angle emphasized the legs and feet of the beer porter. I am very fond of the lens I used. It is a moderate wide angle, and I can shift it without moving the camera. In this case, the lens, called "P.C." for Perspective Control, moved upward so the horizon dropped down to the bottom of the picture. As a result, the vertical lines on the truck, the building, and the cases of beer stay vertical and accentuate the diagonal of the cartons on the hand truck. If I tipped the camera up with the lens, the lines would seem to converge as railroad tracks do going off into the distance.

There I was, happy as a clam, on my belly, lines straight, in color on the six o'clock news.

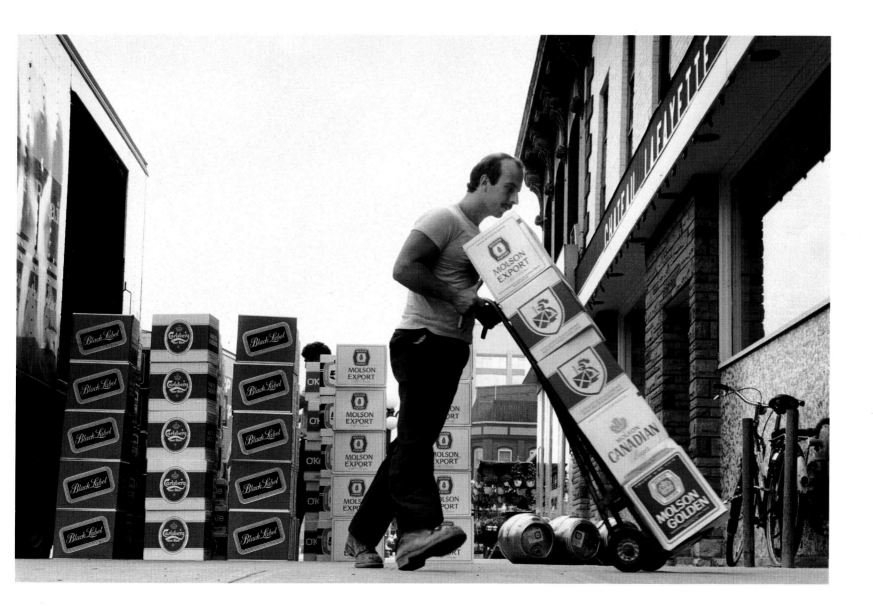

CONSTRUCTION OF THE QUEEN ELIZABETH II, 1968

When I began to take pictures forty years ago, I wandered around Central Park in New York and Nantucket Island in the summer. I photographed buildings, lighthouses, stairways, trees. The only people I photographed were my family. Then at school I started taking pictures of football players for the school newspaper, and I found that journalism gave me an excuse to enter other people's worlds. Since then I've gone past many doors, but I still feel I am a photographer who happens to be a journalist, not the other way around.

Photography and journalism mix well. Consider the ship, the Queen Elizabeth II built in Glasgow, Scotland. How big is she compared to a man? The camera records that.

What is the shape and spacing of the portholes? The camera shows that, too. These are facts that a writer or painter, working as a journalist, has to count and labor over to include, while the camera records them automatically. I sometimes think my job as a journalist is only to carry the camera to the subject, then point it slightly askew, so the record won't be boring. While I waited on the dock at quitting time, an eerie tension built up. Workers, who were putting the finishing touches on the ship, appeared at the top of the gangway to wait for the final whistle. My interest turned from the vessel to the stately flow of the Clydeside workers as they began to stream off the ship.

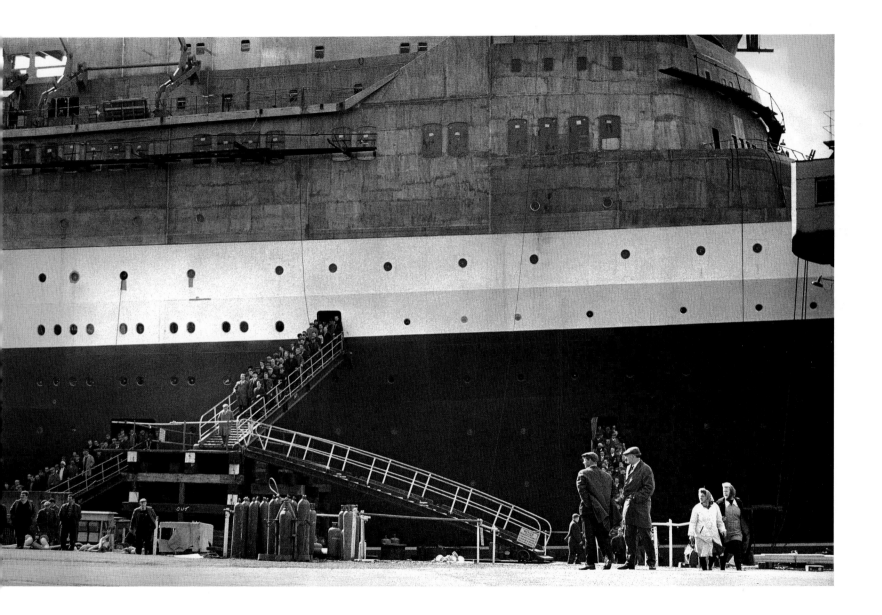

QUITTING TIME ON THE QUEEN ELIZABETH II, 1968

The Clydeside workers came off the ship at a slow and regulated pace only until they reached a point on the dock. From there it was a dash for the gates. I suppose you can't let people run off a ship at quitting time. They have to wait until they are on firm ground. I'd switched from the wider angle of view of the 65mm lens I used in earlier pictures, to the narrower angle of 90mm because I wanted to isolate the faces against the hull. My interest turned entirely from describing the ship to describing the workers.

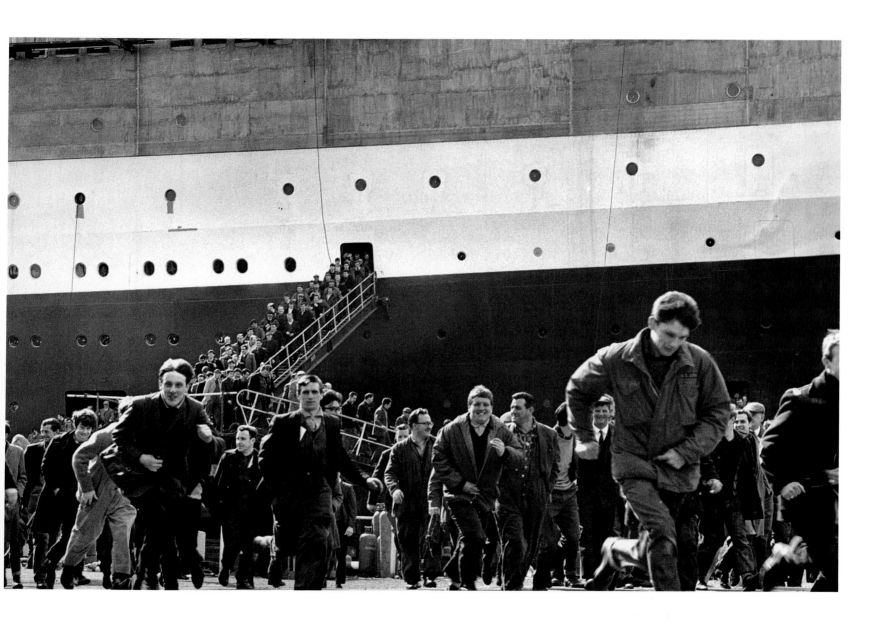

SUPPER INTERMISSION, GLYNDEBOURNE OPERA, 1968

I'm pleased I was able to make so horizontal a composition work. However, it's not the composition that makes the picture interesting, it's the juxtaposition of evening dress and bucolic scenery. Still, while the subject of the photograph is faithful to reality, it is different from it. The sky is not blue. The grass is not green. The skin is not pink. There is no motion. The fact is the objects in front of the camera interelate from one point of view, at a single moment, on one type of film, in a certain light, and any change will change the picture. Lower the sun, turn a head, drop an arm, color the sky, and the photograph will be different—not because the subject is different, but because relationships have changed.

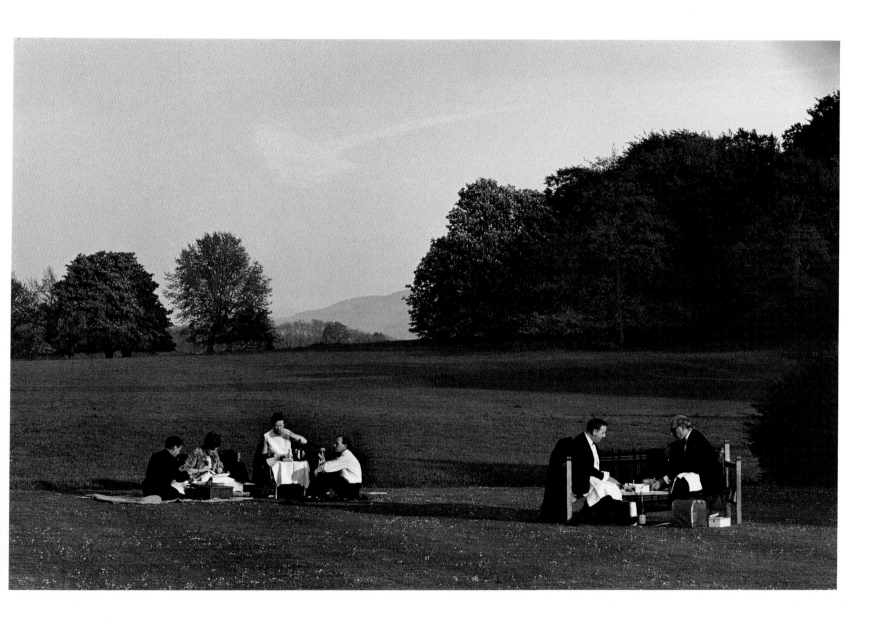

MINIATURE VILLAGE, CANBERRA, AUSTRALIA, 1981

I thought there might be something in the scale of the village that would make a picture, but I couldn't find the right spot from which it would look surprising. I tried it with a gardener in the middle. He was too big. I tried it with the real landscape showing behind but it was too distant and looked in scale, not out. Finally, I asked the owner if any of his cats wandered through the village. "They might," he said. "Might" often translates as "will" to a photographer, and the proprietor was happy to plop a cat into the village. The cat does add scale and surprise, but it's the owner's knee as he hops back out that provided the sense of a moment.

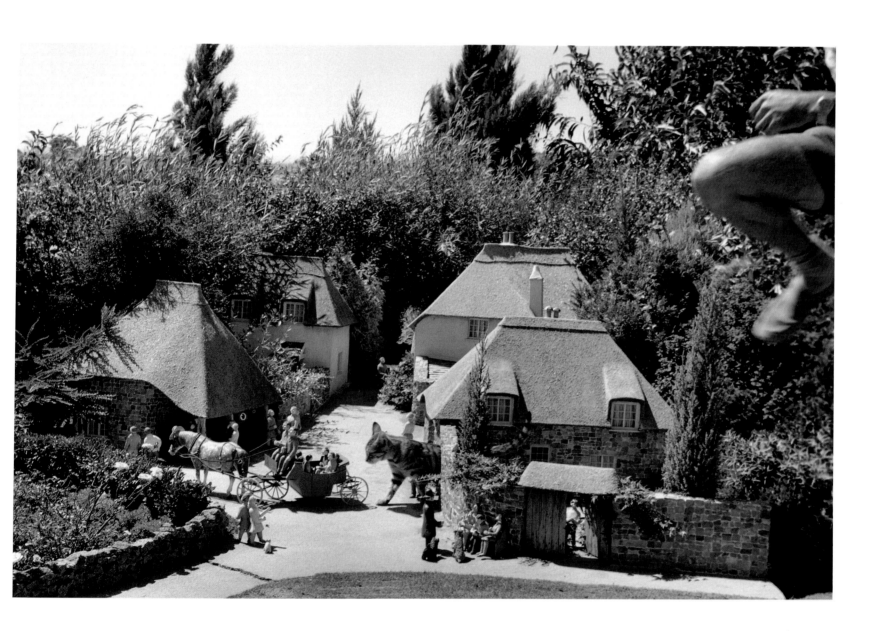

CHILDREN IN MANCHESTER, ENGLAND, 1968

I don't remember taking this picture, which means I did not think it was very good when I took it. I judge a picture only as I hear the shutter trip. It's either "Unh-unh" or it's "Whooppee!!"—some of the latter may actually turn out well. I don't suppose hunters remember their misses and writers certainly don't try to remember every bad phrase that comes to mind. At the time I must have thought the scene was too pat, but what I did not notice was the bit of awkward tension between the children's figures as they walked down this alley.

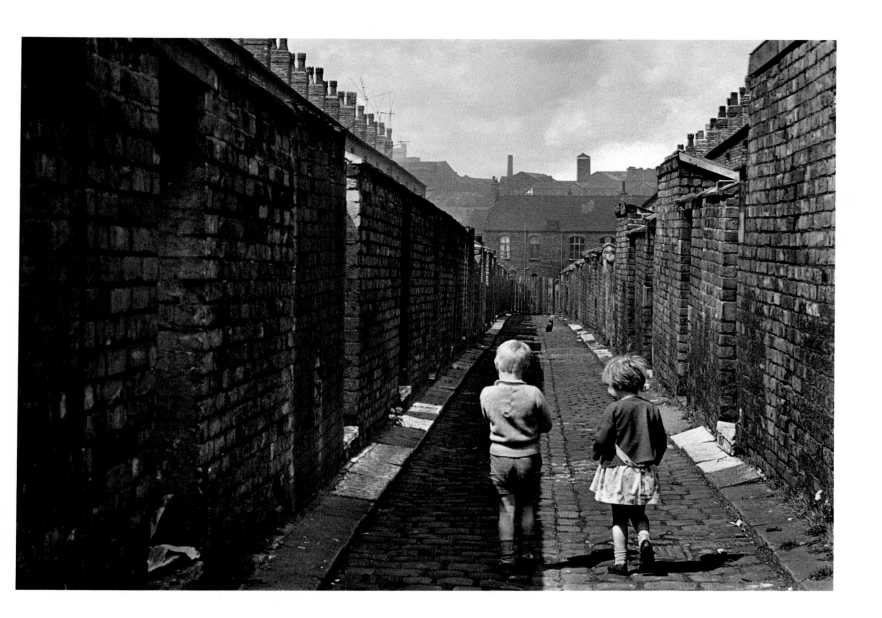

OLD ORCHARD BEACH, MAINE, 1972

In the early 1970s, there was talk of allowing oil supertankers to unload in the deep water bays off the coast of Maine. Some people up there were for it; some were not. It was a tough story to photograph because nothing had happened yet. Along the way, a *Life* editor in New York, Don Moser, commented forcefully that as far as he was concerned I'd shown him how beautiful the coast in question was, but he hadn't seen an example of the awful hand of man working on it. Where had things gone wrong in the past?

I couldn't think of much. People suggested motels on the shore, but at their worst they had a quaintness out of *Psycho*. Besides, I thought Don's idea was journalistic knee-jerking. You do one side of the question, then you show the other. It was also a time when many photographs were being published of car dumps and labeled pollution. The subject seemed a cliché.

However, I agreed to look and figured if there was any place on Maine's coast that might look as if man had clobbered it, it would be along the southern coast where sandy beaches bring many tourists. I went to Kennybunkport, where I found the summer cottages shoulder to shoulder for miles along the shore. The architecture was not by Le Corbusier, but it is hard to disturb a great Atlantic Ocean sand beach. With this in mind, I wandered out onto the remains of the great amusement pier that gets shorter and shorter after each storm. I noticed the glint of the sun shining on the telescope. This is not a pleasant beach scene, but it is a perfectly natural scene for an amusement park area, and I thought it was a photograph of Old Orchard Beach as Old Orchard Beach would want to be photographed. It did the trick, and I know the pier is still there because the young son of a friend said it surely couldn't be the place he'd recently visited. The telescope there, he pointed out, cost a quarter.

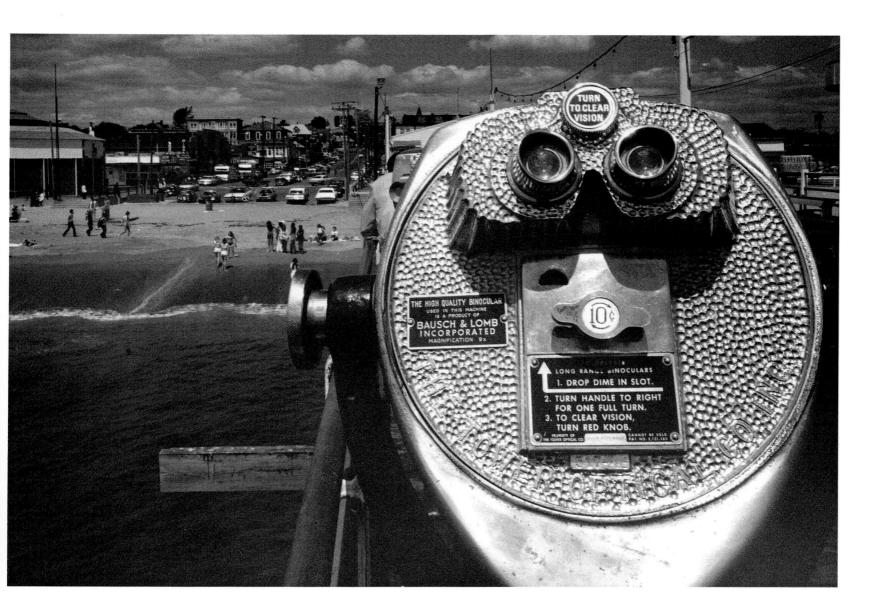

HORSE AND QUEEN ELIZABETH II, 1968

I was working in Scotland. I had already photographed in the shipyard when I noticed the farm country across the river. I went over to see what the farm country would look like in the foreground with the shipyard behind. The Clyde is a very small river and very deep. Horses were grazing on the hill, going for shelter on the typically Scottish day, misty, showery, and cool. One horse came over to me. It's a little corny to have him in the foreground, but he's livelier than a cow.

There are two ways to compose a picture: From the center and to the edge. Alfred Eisenstaedt, for example, composes most of his pictures like flowers. There's the subject like the stamen in the center surrounded by harmonious elements like petals out toward the edge. As you approach the edge, the elements are less and less important to the picture. Often the negative can be cropped a bit and the composition will not suffer.

The other way is to compose the picture all the way across the frame with no precise center to the photograph. For instance, if you put your thumb over the horse's head, the picture is still somewhat interesting. But if you cover up the ship or the horse's chest you change the photograph radically.

A center composition is more pictorial and makes a stronger statement of the photographer's choice of subject. "Look at my subject," it says, "Notice how I've set it in my picture." The frame system says "Look at my scene. See how everything is related." That's the system I prefer.

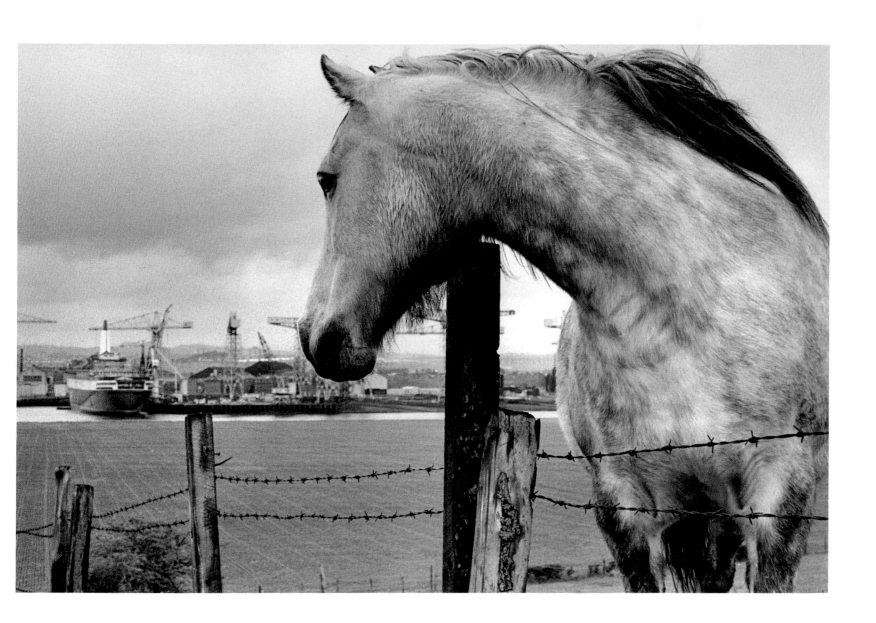

MERCE CUNNINGHAM, 1971

First I was interested in the contents of Merce Cunningham's pockets. He emptied them at the start of every class. Stopwatch, keys, and a notebook with floor plans and choreography were tossed on a chair. I didn't interfere at all, or suggest where he put them so they would photograph well, because I was sure he would only suffer my taking pictures if I stayed out of the way. I tried photographing the contents on the chair, but by themselves they weren't interesting. Next, I tried photographing Cunningham himself with a long lens from the far side of the room, but the windows behind him caused a glare and gave a scrappy appearance to the picture. Then, with a normal lens, I photographed him demonstrating moves to his dancers as they came near me on the edge of the floor. But it was not until I plunked my tripod down directly behind him that I found a picture I really liked.

My rule in a situation that is promising but not productive is to find a good spot with good light and something interesting (in this case, the contents of his pockets). I sit down and make myself comfortable and study the scene as I would from a seat in a Paris café. As I get comfortable, I see more.

My view was mostly of an empty room, so I needed to wait for the dancers and Cunningham to fill the space. He sat down first and then, as luck would have it, the dancers took positions that mimicked the shape of the folding chairs.

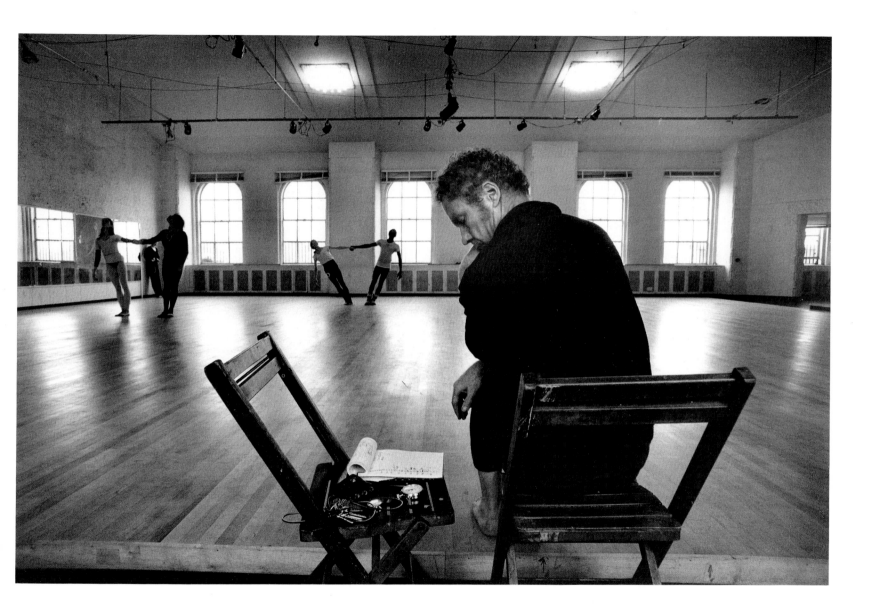

EMANUEL AX, 1978

Emanuel Ax rehearsed at the home of the con-
ductor of the Wichita Symphony, Michael
Palmer, and his wife. One of the things that
has always bothered me about the picture is
that I know how loud Emanuel Ax plays and
Mrs. Palmer would not be sitting in that seat
unless some photographer asked her to. It
would be like sitting in the middle of the
piano. But if she weren't sitting in the picture
there would be nothing in the left side of
the frame.

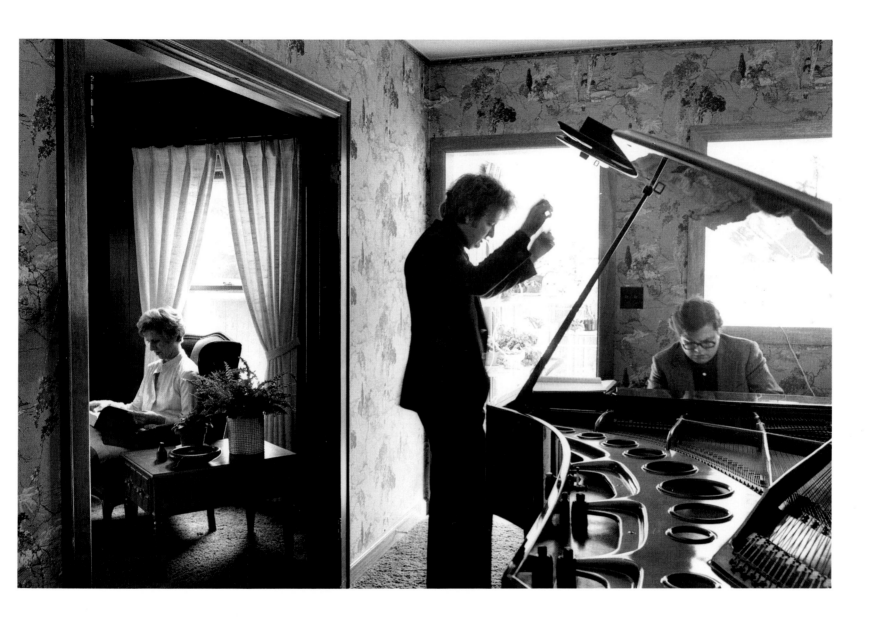

PHILIP PEARLSTEIN, 1966

Why black and white? Well, what would color add? Would it show the color of the walls? The color of the paint splattered on the floor? The color of his shirt? The color of her skin? That additional information would make it even harder to notice that his arms mimic her legs, and that this photograph is about the relationship of things: A painter to his model. A model to a room. A painter to his work.

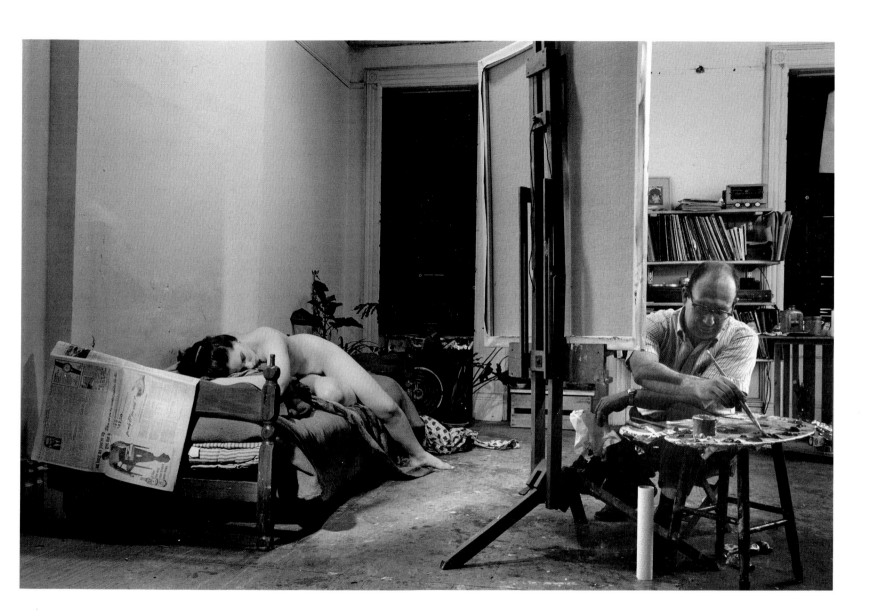

JOHN SWONGER'S ROOM, 1977

I did a story on John Swonger in McKeesport, Pennsylvania. He worked in a steel plant and lived with his parents. One afternoon I photographed the football players he had painted on his bedroom wall. At the same time, I wanted to show what he had on top of his bureau and I also needed him in the picture for scale and human interest. I did not need to show his face, because I'd show it in the other pictures in the story and therefore I could easily ask him to stand motionless but still suggest motion. If the closet door were clear glass, this picture would be impossible. I just asked John to stop where he was and hold the door open. If I could see his face, it would look self-conscious or bored.

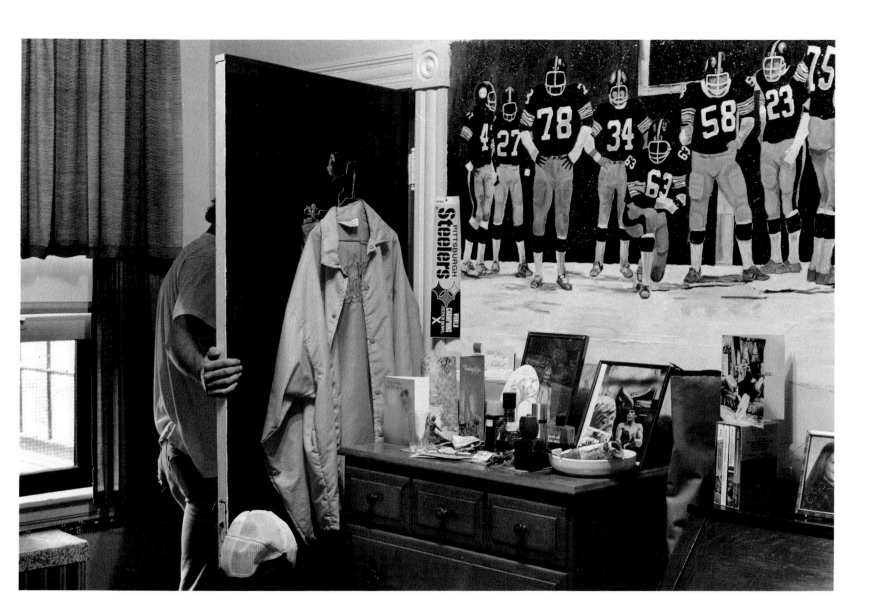

JENNIFER LOENGARD, 1983

If I take a picture of my daughter, our relationship changes and she is not my daughter any more. She could just as easily be the Duchess of Malfi. If she says, "Oh, Dad, not now!" I'll treat her exactly as I would Georgia O'Keeffe if she said, "Oh, Mr. Loengard, please not now!" In my head I think, "There is a beautiful picture here and by God, short of murder, I'm going to get it. So shut up and hold still!" But what I say is: "You look wonderful. It'll just take a minute. It's marvelous. We're doing something very special!"

I learned the part about a minute from a dentist. I learned the rest from Carl Mydans. For the magazine's thirtieth birthday, *Life* pho-tographers were asked to photograph each other. Carl was assigned me. To see such an intelligent and distinguished man concentrate on the problem of taking my picture was extremely flattering. Still, I felt tense. After all, I was being scrutinized. Carl kept telling me what wonderful pictures were being made. I believed him, and soon I relaxed. I was a success at being a subject!

(You should tell these things to a person as you photograph him—even if it's a lie— which, in this case, it was. *Life* photographers, as it turned out, could photograph anything in the world except each other.)

CHARLES IN THE BARN, 1967

I had come to believe that if I earned my living photographing other people and their families I should also take good photographs of my own. I thought I should feel the same way photographing my son Charles, age three, in the barn at the house we had in Maine as I did photographing someone else's boy, except that maybe knowing more about Charles, I might do him better.

He liked the swallows flying high above his head in the rafters. The truth is, I have photographed no other three-year-old boys as they explore their world, so I can't say for sure if loving Charles has made this a better photograph.

ELLIE IN BOAT, 1966

This picture grows out of pride of ownership. I'm partly a land owner photographing my property and partly a photojournalist trying to do a story. When we bought a house at the top of this field in Maine in 1966, I thought I should get a wonderful set of pictures of the house and land. The place excited us a lot— the house was perfectly all right, but the land and particularly the field were wonderful.

I had done a story on the view we had from our apartment on Riverside Drive in New York City because I'd decided that if I was a good photographer, I should be able to point my camera out the window and take good pictures. I did not need to wait for assignments or travel to far-off places.

Our boat could come up to the edge of the field only six hours on a tide. For the other six hours, there are mud flats stretching half a mile.

I have made no attempt to deal with personality at all, yet you get a definite sense of Ellie's character from her very straight New England back. Her hair and the pines mimic each other and Charles' arm lines up with the sides of the boat.

A Ming vase can be well-designed and well-made and is beautiful for that reason alone. I don't think this can be true for a photograph. Unless there is something a little incomplete and a little strange, it will simply look like a copy of something pretty. We won't take an interest in it. What makes this view arresting is that the woman's back is toward you, like a ship's masthead heading away to a very special piece of land.

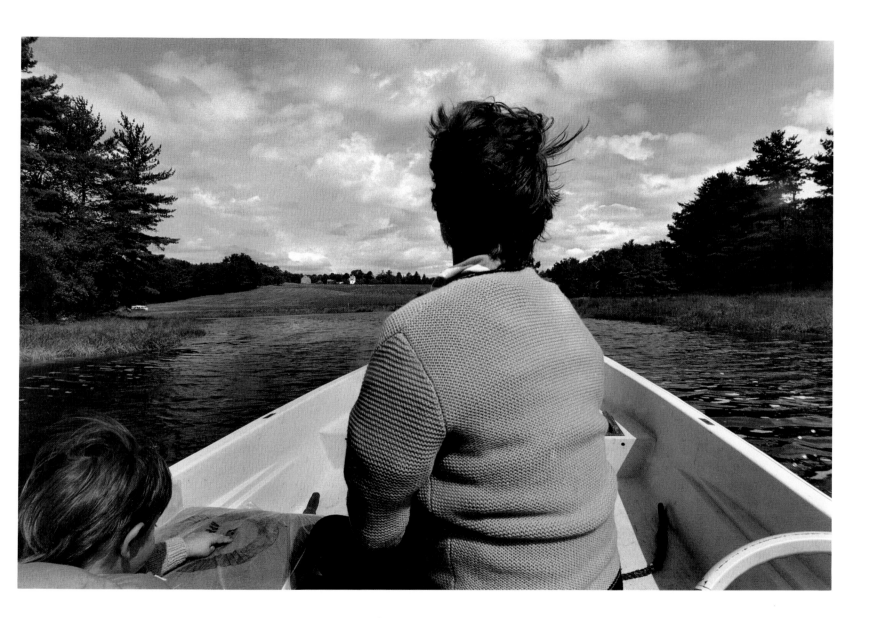

LEONARD "BUSTER" VIOLETTE, 1975

Jan Mason, a *Life* editor, sent me a clipping about the end of the log drives down the Kennebec River in Maine later that summer. "Why don't you?" was scribbled on it. My summer house was near the mouth of the river, so when I next was there, I went up to meet the foreman of the drive, Leonard "Buster" Violette, at the spillway near Bingham. The logs had to go through the spillway in a chute, so they collected on the north side in a great raft. It was easy to use the sun as a spotlight and ask Buster to look up into it while I could see the river spread out over his shoulder. This was not the last raft of the summer, there was more than a month of work to go, but it was the last summer there were any logs in the river. Their bark no longer contaminates the water to make it poor for fish, and half-submerged logs do not break the propellers of power boats. The logs now ride south on trucks.

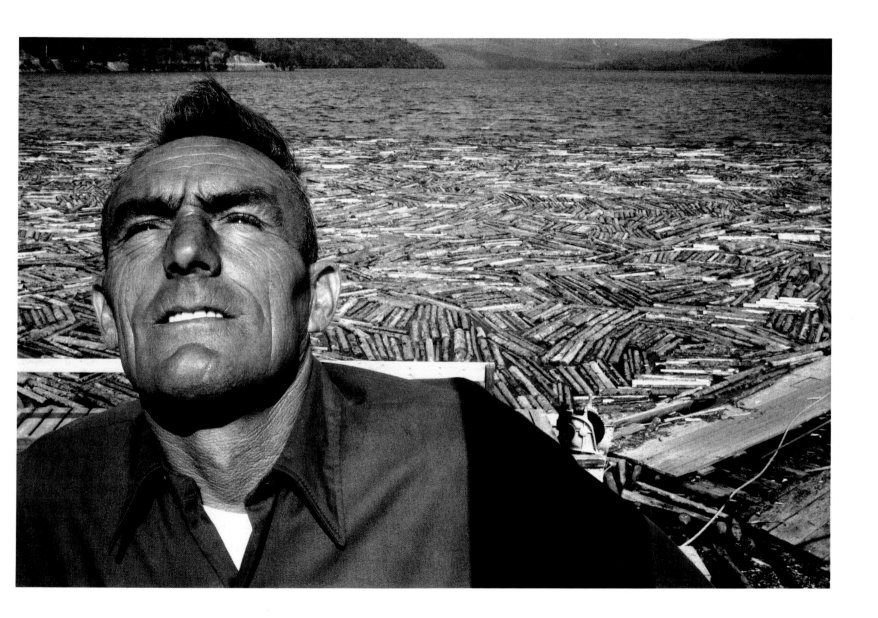

STEFAN LORANT, 1982

I like sunny days and the limitations they present. A person has to be in a certain relationship to sunlight. You have to work with the direction of the light.

I spotted the sun on the staircase. I thought, "If I ask him to sit here I will get a picture." There was a framework for it. It was all squared off and everything was in its proper place. It was a ready-made picture like a ready-made suit. Stefan Lorant was the right height and size, but Franklin D. Roosevelt or my father would also have fit if it were their house.

There is nothing that unusual about sitting on steps and Lorant is a reader. There are books all over the place, but still when I asked him to sit I asked as if it were an outrageous suggestion: "Ever in your life have you...?" What could the answer be but yes? He sits. It's a little performance, but the performance is interesting because the stage is set. The book gives him something to do.

The light comes from the right and bounces up off the rug, so it's coming from below and this is peculiar. It's as if Lorant had footlights in his living room or a fireplace at the foot of the stairs. It's a bit peculiar to see a nearsighted man sitting on the steps reading a book. It's a bit peculiar that the pages blur. Three little peculiarities. If it had been a cloudy day we'd have lost one of them. If we'd have lost one of them, we'd have lost the picture.

You do not see a definitive action. You might think he's reading a book. You might think he's glancing through it. You do not quite know. You have a very concrete situation and a slightly ambiguous act.

Again, if you put a cloud in front of the sun, the clock would lose its brightness; so would the wall and the rug. Everything would be evenly illuminated except for the bright window. There would be no splash of light. The moment's static nature would increase. Sunlight gives the light direction and a sense of motion. There is the sense that the light is this way now, but soon will change. Perishability is important in a picture. If a photograph looks perishable we say, "Gee, I'm glad I have that moment."

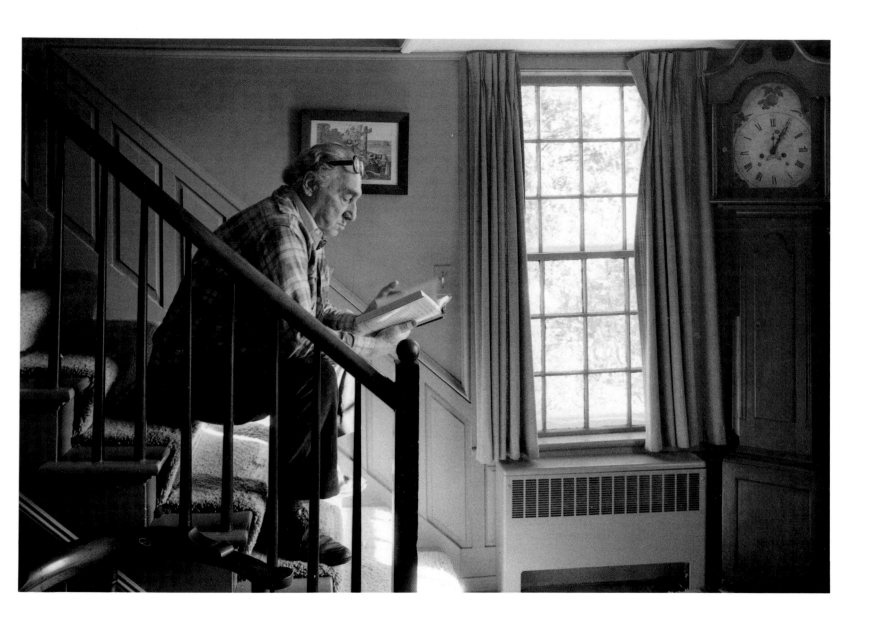

STREETSWEEPER, 1968

He looked majestic on a London side street. I asked Frank Allen, the London bureau's driver, to stop the car and let me take pictures. The man snapped to attention, like a soldier, broom on shoulder, to let me photograph his dignity.

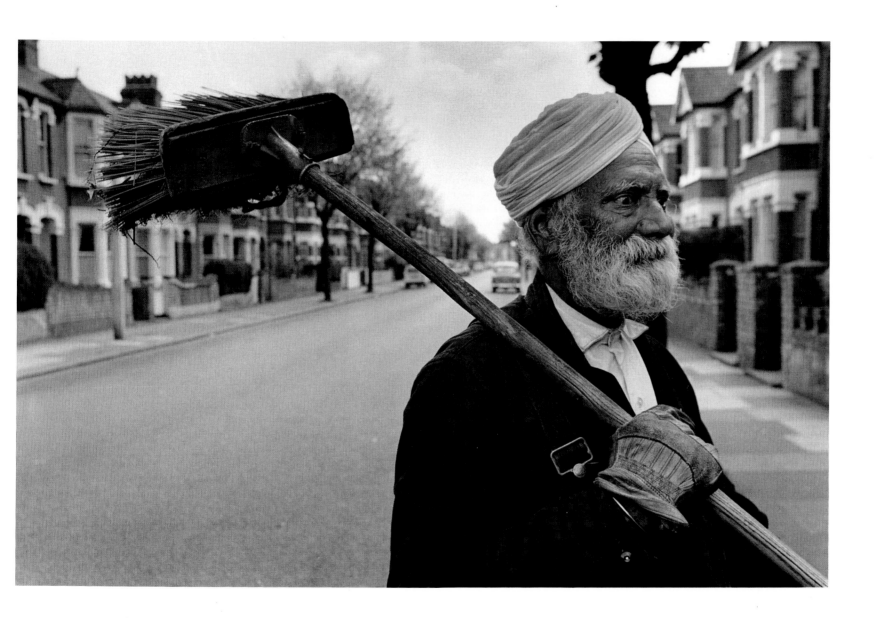

GJON MILI, 1983

Here is a picture I never wanted to take. Gjon Mili's mind was going. He soon went into a nursing home and before a year went by, he died. Someone who saw him daily suggested that if I wanted to photograph him, I had best do so quickly. I went down three floors in the Time & Life Building to his office. "Gjon, I want to take your picture." "Yes. All right." He knew why I had come.

For the last five years, since he had been hit by a taxi while crossing Fifth Avenue, his mind had become a deep cave from which he got smaller and smaller glimpses of the outside world.

Gjon had been born in Albania, raised in Rumania, schooled at the Massachusetts Institute of Technology, and trained to be a lighting engineer. In 1937, he met Professor Harold Edgerton, the inventor of the strobe light (the high speed flash of light that can stop the motion of a bullet in flight) and told him he'd quit his job as an engineer to become a photographer if the strobe could be made brighter to illuminate large areas. Within a year, Professor Edgerton made the strobe twice as bright and a new film, twice as sensitive to light, came on the market. Mr. Mili became a photographer.

He pioneered the use of strobe light in photographing sports, the ballet, political conventions, and the theater. He used it to prove that a baseball pitcher's curve ball does not curve. Although almost all his work was done for *Life* magazine, he refused to join the staff or sign a contract. He was proper, proud, cantankerous. He also helped young photographers whose talent he admired.

I met him in 1966 after his studio on 23rd street burned down, and he moved into an office at *Life* with all the negatives and transparencies that had survived. His lighting equipment was lost, and he never replaced it. I spent evenings with him at a nearby delicatessen or, a few blocks further away, at the Greek cafeteria, Molfetas. I guess we spent our time trying to explain photography to each other. He became an informal advisor to the *Life* Special Reports published from 1973 to 1977. About the time the monthly *Life* started in 1978, he had his accident and his decline continued steadily until that day I came down with my cameras.

Completely lucid, I expect he would have scoffed at my two presumptions: (a) That I could take a good picture at all (he did not consider that certain) and (b) that he was a fit subject for a photographer. Picasso? Yes. Picasso was worthy. Sophia Loren? Of course. Ballanchine's dances? Twyla Tharp's? Yes, yes. Of course. He'd show you his work. John Dean being sworn in at the Watergate hearings? Very important. He admired the hearing's chairman, Senator Sam Ervin, with a passion. Every night while covering the Watergate hearings, he'd retired to a hot bath with two Rob Roy cocktails, then he'd call me to say how the day had gone. He was nearly seventy. The photographs were classic.

I asked him if he would put his elbow on the light table. Slowly, slowly, slowly he responded. I had placed a light of mine to shine on the wall behind him to avoid the dreary sameness of flourescent office light. By coincidence, engineers, trained as Mili had once been, are the bane of photographers. Their dictum that onto every desk the same amount of light must fall produces a democracy of light that is very boring. What's more, it lights the tops of heads better than the faces. My own light made the wall of clippings and mementos bright. Still I could not make the photograph I wanted. The background remains separate from the foreground. If you take out the very center of the picture, the face and hand, there is nothing to the picture. No rhythm. No structure. No design. But the face and hand are interesting. A light from somewhere reflects in his eye and gives it focus. That was it. That was my last sight of Mr. Mili.

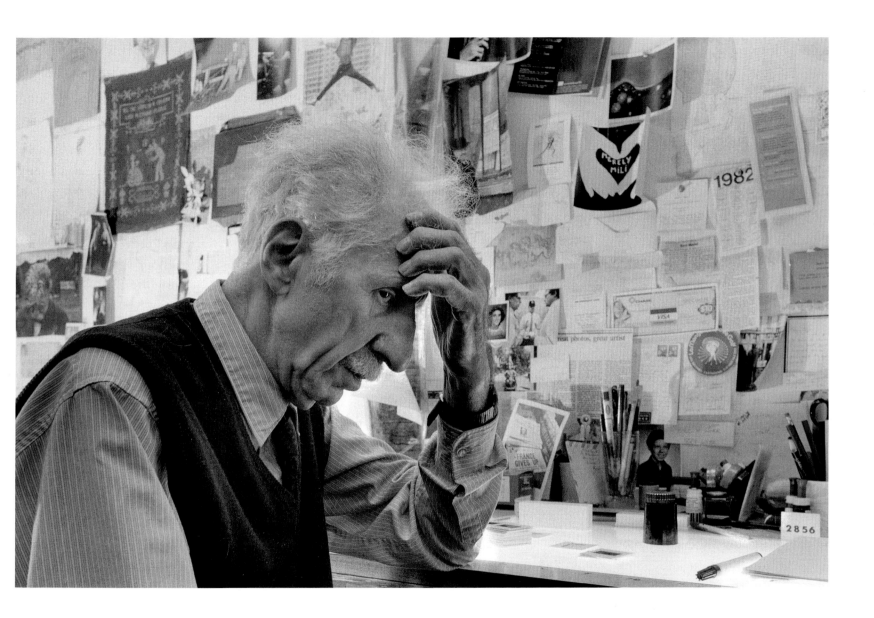

ACTOR IN LOS ANGELES, 1969

Hands photograph well because they are what they are. We don't put them on diets. We don't inject silicone into our thumbs to make them prettier. Like feet, they lose their baby fat and take on character early. They are always on my shopping list when I do a story. Feet would be on the list too, but shoes ruin them. In countries where people go barefoot, feet are quite interesting to photograph.

This actor's arm and hand, alone with his publicity stills, formed an eloquent unit. If I'd included his face, it would have stolen the show. Not because it was beautiful, but because in our eye, ear, nose, and throat society, that's what we'd look at.

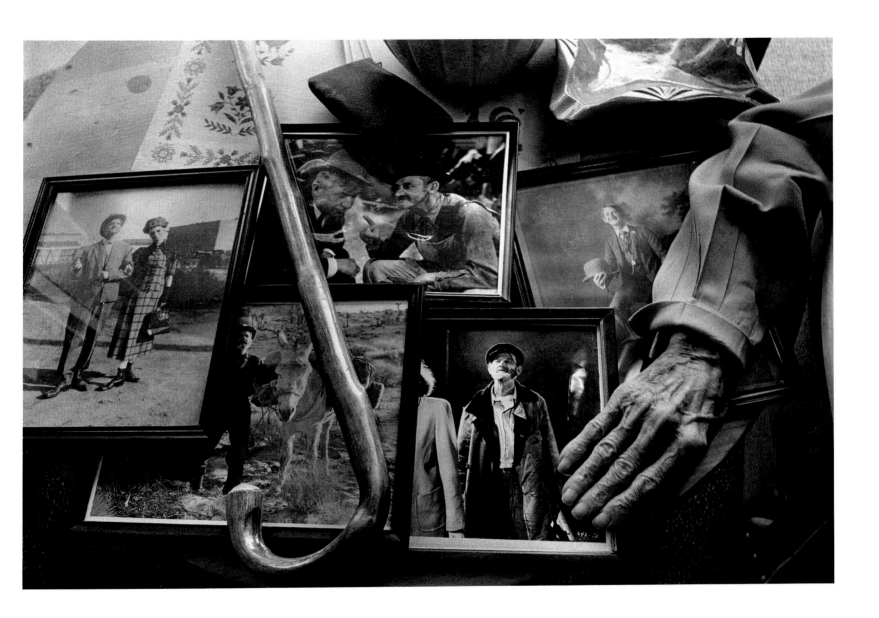

PAGES FROM *LILLIPUT*, 1982

Stefan Lorant founded *Lilliput* in England in 1937. It was a lively magazine distinguished by pairs of photographs he purposefully juxtaposed on its pages. Lorant was born in Hungary. After trying to be a film director he moved to Germany where he pioneered picture magazines. Hitler put him in a concentration camp and on his release, Lorant went to England and founded *London Weekly Illustrated* and *Picture Post*, as well as *Lilliput*, the magazine he's holding in his hands on the porch of his home in the Berkshires in Massachusetts. He came to the United States in 1940 and published a number of distinguished illustrated books on American history. It was he who hired W. Eugene Smith to go to Pittsburgh for a few weeks when Smith left *Life*. Smith spent two years, and Lorant had great trouble getting his pictures.

We had been sitting in his living room looking through old magazines, and I was trying to figure out how to photograph this charming representative of photographic his-

tory. I decided to leave his face for the next day. (If things aren't right, it's good to leave quickly, arranging to come back at a time you think will be better. We were losing the sunlight behind clouds, and his sons had guests. I thought that it would be quieter in the house after breakfast the next morning.) But before I left, I tried one thing. His enthusiasm as he looked at the layouts of picture stories from Germany and England before the Second World War was contagious. Many were examples of picture stories that have been done again and again since, but here they were new. I wanted suddenly to juxtapose them and the autumn tranquility around us. I asked Lorant to bring out the anthology of *Lilliput* because its small format was in scale with his hands, and it would be easy to hold.

"The printer was sure I'd made a mistake, so he switched the captions!" he said with glee. "*The Ripe Pear* has to go under the guy, on the left and *The Jolly Publican* on the right. I made them get it right for this anthology!"

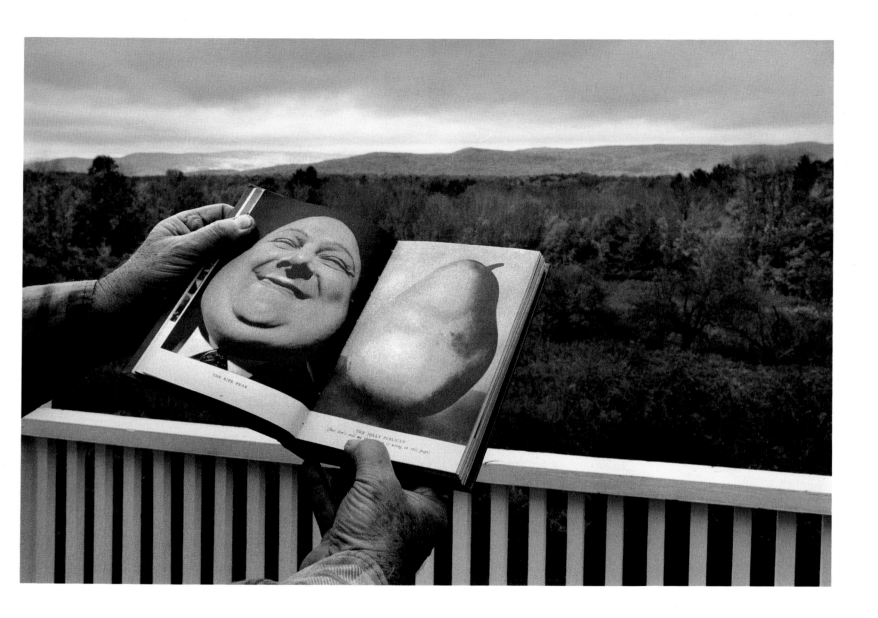

ANDRÉ KERTESZ, 1981

I have never seen a bad picture of Hitler or Himmler. They look as good as Churchill or Roosevelt. Curiously, you can only photograph the yesses about a person. You can't photograph a person's absences. If Hitler has no heart, you can't photograph it. It is the presence of things that you can shoot.

So when André Kertesz was telling me how the Museum of Modern Art required him to crop the pubic hair out of his picture, I had a problem. Mr. Kertesz was still vividly outraged by the forty-five-year-old example of American morality, and I asked him to show me. I faced a dilemma: If he placed his hand accurately, I would not see what was left out; if he did not place his hand at all, I'd be copying a page in a book on a table. Mr. Kertesz knew what to do. He left a little showing.

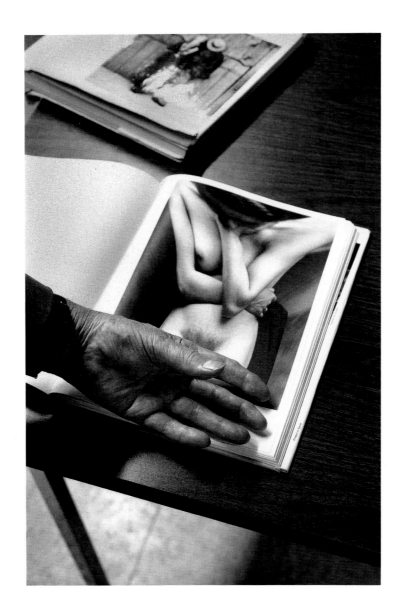

SWAN, 1968

I was in England, standing on a bridge over a stream filled with swans. It seems impossible to go wrong photographing swans. Even when they stand on one leg in the shallow water and preen themselves, they have great beauty. The photograph records one bird's wonderful shape. I have added nothing to its form. I have related it to nothing. I have done no more than isolate it, which is the most important control a photographer has.

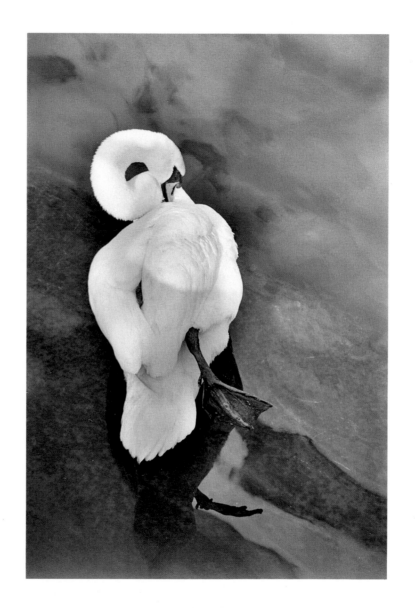

DIZZY GILLESPIE, 1972

You start having technical problems when some manufacturer says he will pay you ten thousand dollars to photograph his computer and make it interesting. That poses a technical problem. If you can do it with imagination and skill, you have earned your ten thousand dollars.

I do not think I have become more skillful as a technician over time. I think I have become more skillful at finding pictures that fit a very simple technique. Many photographers end up doing that. You have to learn what you can do well. I think style in photography is like running the last mile in a marathon. You run the twenty-sixth mile any way you can. My pictures reflect the fact that I'm trying as hard as I can, and I can't do anything else.

Dizzy Gillespie met me in his manager's apartment and showed how he usually posed for photographs, with his cheeks puffed out like a blowfish and his eyes popping. Then he showed me how he cleaned his trumpet in the bathtub. I did not see how to make a picture of either performance. I asked him to sit in an easy chair in the sun and close his eyes. Then I worked around him, looking for a picture as I might have if he were a statue in the middle of a park.

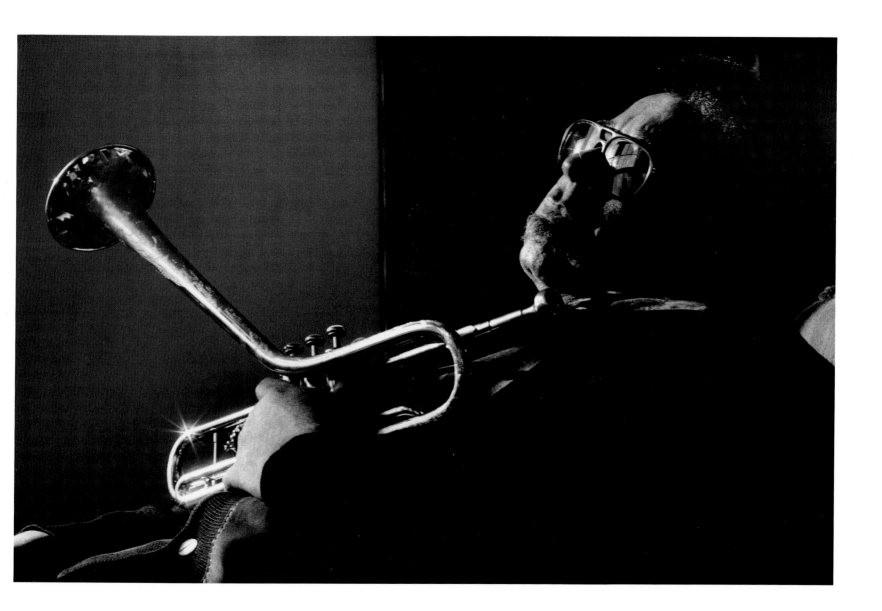

AD REINHARDT'S STUDIO, 1966

I like to photograph in New York City because it gives me an excuse to go into buildings I've passed by many times and see what's inside. Ad Reinhardt, the painter, had his studio in an old building that formed a T with a street running east from Washington Square. It's unusual in the city to look down a street instead of across one, and the view struck me as I walked in. I found myself interested in what was outside as much as what was inside and in several pictures Reinhardt became no more important than the willow branch that frames Mount Fuji in a postcard.

GEORGE NAKASHIMA WITH HIS WOOD, 1969

George Nakashima makes chairs, tables, and cabinets from boards he buys all over the world. I had not known before I met him that when a rare tree is cut down, people bid for slices of it. He showed me some in his small warehouse. It was the time of Zen, Flower Power, and Woodstock and I wanted to show that the craft of this craftsman was not predictable. It involved both exquisite selection and the use of a buzz saw.

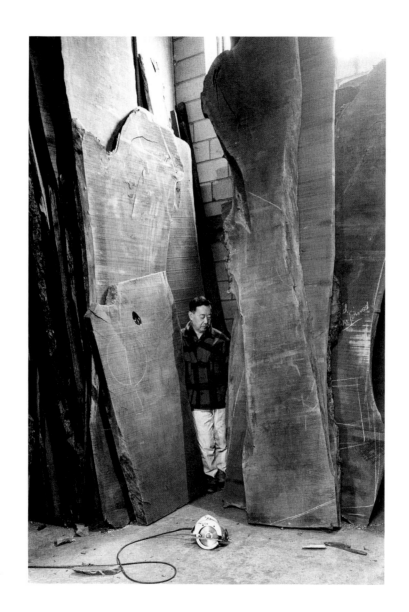

JOHN STEINWAY, 1981

A photographer doesn't ask the reporter's traditional "Who, What, When, Where?" We ask: "Can I go in there?" and "What does it look like when you do that?" We want to see everything before we choose what to photograph. John Steinway was happy to oblige and gave me a tour of the family piano factory (owned at the time by CBS) in Astoria, Queens, across from Manhattan.

We'd met downtown at the Steinway showroom, and while it's true the light there was not especially good for photography, the real truth was that I had no intention of taking any pictures before I'd seen the factory. Steinway told me how to come out later in the morning ("Take the BMT to the end of the line then walk a couple of blocks.") and I found an old building with pianos in various stages of construction, just as I had dreamed.

It is natural to turn the camera to the vertical when taking pictures of people, but I rarely do it. In magazines the largest pictures are horizontals (because of the shape of two pages together), and I suppose that's been an influence, but the main reason is that in my twenties I decided to make my portraits wide instead of high. Going against what was natural, I thought, would increase my mastery of the camera. Now it's rare that I ever use the camera vertically, and only the obvious ease with which these piano sides standing by the kiln could balance Steinway's standing figure led me to do it. Besides, I did not see how to make a horizontal composition out of this scene, and it was easy to find the spot where placing a live Steinway in harmony with wooden ones was all that was needed to make a picture.

AD REINHARDT'S PAINTINGS, 1966

What Ad Reinhardt did was quite wonderful. The subtly different, near-black geometric shapes in his paintings came back from a show in Los Angeles scuffed, so he just repainted them and hung the canvasses up to dry in his studio.

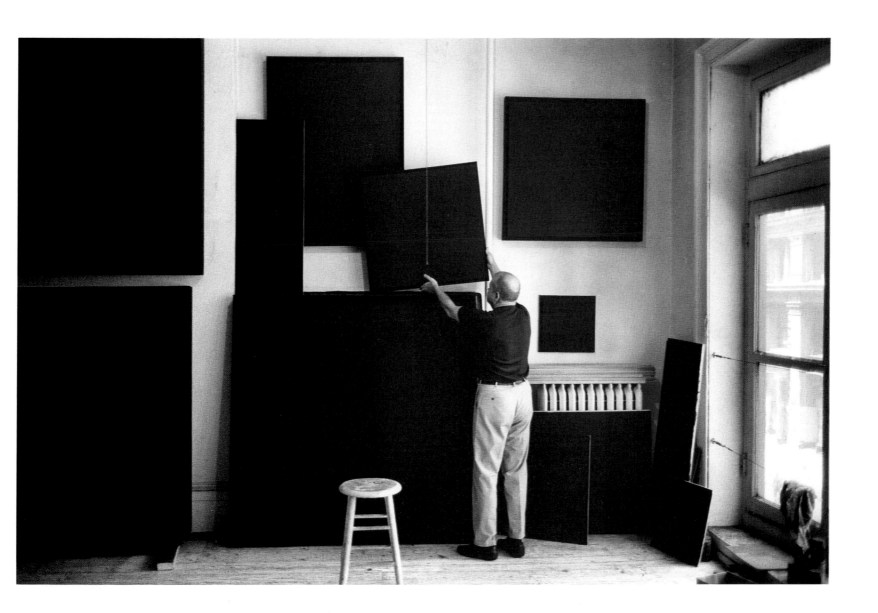

KARSH'S NEGATIVE OF WINSTON CHURCHILL, 1984

Yousuf Karsh took this picture of Winston Churchill in 1941. He says he caused Churchill's fierce expression by snatching away the Prime Minister's cigar just before the picture was taken. I wanted to photograph the negative that was in the camera that day.

I planned to come to Ottowa as one of the hundred photographers working on the book, *A Day in the Life of Canada*, orchestrated by Rick Smolan. I wanted to photograph my friend Karsh, but he had to be in California. I asked if I could photograph the negatives of some of his well-known photographs. "Of course," he answered. "The one of Churchill?" "Certainly, John."

We confirmed a week ahead. "The original negatives are in a bank, but I have made arrangements with the manager there. You can photograph them in the bank or in the studio. Whichever you prefer. My staff will arrange whatever you need." Karsh's courtesy is so unfailing that I can't imagine he really snatched a cigar from the Prime Minister's mouth. And if he did, I'm sure Churchill would have smiled.

The morning I arrived it was hot, and I was lazy. I did not want to traipse over to the bank. I asked Karsh's assistant if he would bring the negative to the studio that afternoon. When I came back there was a negative on the light box and although it was of Churchill, it was strange. It was trimmed down to $7\frac{1}{2} \times 9\frac{1}{4}$ inches, not the full 8×10 of an original. "Who would cut the negative that made Karsh famous?" I asked myself. "Either Karsh has more daring than I ever dreamed or this is a copy negative he uses for routine prints."

"Is this the original negative?" I asked. I thought I saw a flicker in the assistant's eye who answered, "Yes. This is the original." What could I do? I did not want to make a fuss and call Karsh in California. Obviously, the assistant did not want the responsibility of bringing the negative out of the bank when Karsh was out of town. I was not happy, but it was entirely understandable.

Anyway, I took a picture that I like by asking Ignas Gabalis, Karsh's printer to hold the copy negative, and I have a standing invitation from Karsh to return and photograph the real thing, so I may end up with two pictures I like instead of one. But that is not the point.

In the classes I teach there is always a student who announces that photographs lie. "They do?" I ask. "When was the last time one lied to you?" The answer always turns out to be that the caption was wrong or an advertising slogan was not to be believed or the scene recorded ran counter to the viewer's expectations. No one has yet remembered a photograph lying on its own, but I remember the last time I was lied to by a human who looked me in the eye and told me something we both knew was not true. I remember it vividly. I remember my reaction.

Okay, but why bring it up now? Because to understand photographs, I believe you have to understand that the camera just shows what it shows. It may sound important to speak of moral shortcomings in photography, but I don't think they exist. Photographs may be moving, exciting, compassionate, or clever. They may be dull, silly, blurry, or bad. But the camera cannot lie. Neither can a slide rule, a balance, a thermometer, a steam engine, or an atomic pile. If you want to lie, you have to do it with words. I am telling you the truth.

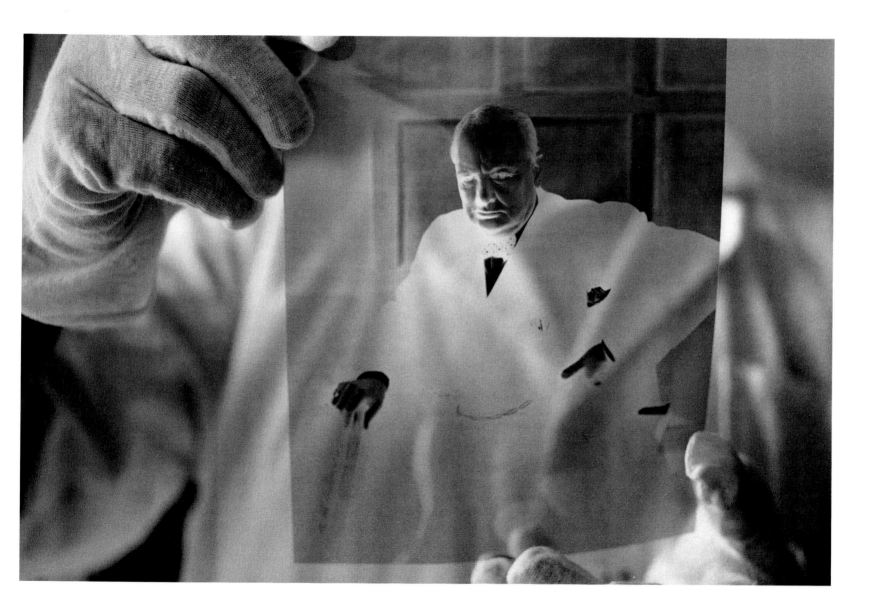

JILL GILL, 1982

Jill Gill has collected rings and bracelets for a number of years along with children, squashed cans, post cards, sculpture from demolished buildings, old tins, Victorian tiles, photographs, stained glass windows, labels, signs from stores, books, bottle caps, the odd fish knife, and the paintings she has made of buildings that have vanished from New York. She wanted a picture of herself and asked me to take it.

I had photographed her once before by borrowing her camera when the light on the street was right, but now she asked me to do a real job. Her apartment had little natural light and every wall was covered with a part of her collections. I have never learned the studio techniques that use lights and background paper to make a portrait. I asked her to stand by a window but the picture I liked best was not the portrait I did, but the record I made when, taking a break, she stretched and bent over to touch her toes.

GEORGIA O'KEEFFE WITH A STONE, 1966

This is a crime photo. Georgia O'Keeffe confessed to me that she had coveted a rock found by the photographer Eliot Porter and stolen it. Here it is. It is true that a rock stolen among friends is not a crime that a court would spend much time with, but this would be a nifty bit of evidence if one did.

HIGH COURT OF AUSTRALIA, 1981

I usually daydream about pictures before I take them. They always turn out looking different from the dream, but at least I have a point of view with which to start. Rick Smolan was the last and youngest photographer I hired to work on the *Life* special report, *One Day in the Life of America* in 1974. Six years later, he called to say he was organizing an identical project in Australia with the same number (one hundred) of photographers taking pictures on the same day. I said, "Oh, boy!" When he asked where I'd like to photograph, I said, "Ayers Rock and Alice Springs."

"Too bad," he said. "Everyone wants to go there. We want you to photograph the Prime Minister." Of course, that may sound like an honor, but I've never seen a Prime Minister who's as spectacular as the Australian outback. "Okay," I said, "but if I have to go to Canberra, I want to photograph the Supreme Court, too."

What I had in mind was not so much a daydream as plagiarism. Yoichi Okamoto had done a wonderful picture of Chief Justice Burger and the rest of our Supreme Court standing casually against a long table, chatting amiably in business suits, each being himself. I wanted to do something like that, but when I arrived in Sydney for the meeting of all the photographers involved in the project there was no word from the High Court (as they call it). When I arrived in Canberra, the answer came: "No."

I told Smolan. The next day the answer was still: "No." The following morning, it was still: "No." At lunchtime, a message came: "Go see the Chief Justice at three o'clock." Who pulled the string I do not know, but possibly it was the Prime Minister, a friend of Smolan's

and a backer of his project. I went looking as sober, serious, honest, and intelligent as I could. (I have a brother and a brother-in-law who are lawyers, so I know what they like.) The Chief Justice was kindly: "We'll do it tomorrow in the robing room just before the session starts."

The Clerk of the Court showed me the room, and I came back the next day, set my camera up, arranged the chairs, and waited. The Justices came in five minutes before court was to start. They sat down and started joking self-consciously about being photographed. They kept joking. I kept snapping. I never asked them to sober up and act like judges. "Thank you. Thank you." They filed out and heard final arguments in a case involving Aboriginal land rights.

VAN DER ZEE PHOTOGRAPHS BLAKE, 1981

Thirty years ago, any small news event in New York attracted twenty or more still photographers. Everyone jockeyed for the best position and the only rule was that you should not block another photographer's shot. If you did you might find the sharp corner of a Speed Graphic camera in your ear. There was no time for explanations.

In 1981, I was midway through a story on photographers born in the nineteenth century. One problem in such a portrait story is finding action and variety, so I jumped at the chance to go to a gallery on Madison Avenue where James Van Der Zee, 95, was to photograph composer Eubie Blake, 98.

Still photographers buzzed around the two gentlemen as they chatted during a preliminary social hour. A photographer would take pictures on the left—click-click-click—then run over to the right—click-click-click—then around behind—click-click-click—and then over to the left again. I think they were taking pictures by the pound. Nothing was happening.

I looked around. I borrowed a ladder to see how things looked from the ceiling. In the end I figured I could straddle an old chest with my tripod and, squeezing in behind it, have a view of Van Der Zee and his wife silhouetted against Blake and the background. I included part of the chorus of photographers.

I waited for Van Der Zee to start. As he did, a photographer, noticing my different position, came over and stood in front of me. I grabbed her by the shoulder and pulled her back, grunting and gesturing to show her how wide my field of view was. (Luckily for her I wasn't using a Speed Graphic.) Van Der Zee made his exposure in a way I had never seen. There was no shutter. He just took off his lens cap and put it back on in silence as we all went click-click-click.

JUDY GARLAND, 1961

Maybe the fact that this is a photograph makes
it easier to accept as real the expression of the
man on the left and the peculiar way Judy Gar-
land bends over to receive the hands of the
audience in Carnegie Hall. Still, this picture
could be a painting. Our reaction to it would
not change.

The forms are interesting, not the details.
His mouth. Her back and head. The flash-
bright fingers in the lower right. They'd be just
as exciting in a gray and black canvas twelve
feet wide. What went wrong? I didn't take a
good photograph, that's what. I fudged details
and relied only on strong form. The camera's
veracity was not needed. I'm not apologizing.
I liked the rawness of the scene and I
recorded it. I like the result even if, sorry, it
could be done as well by hand.

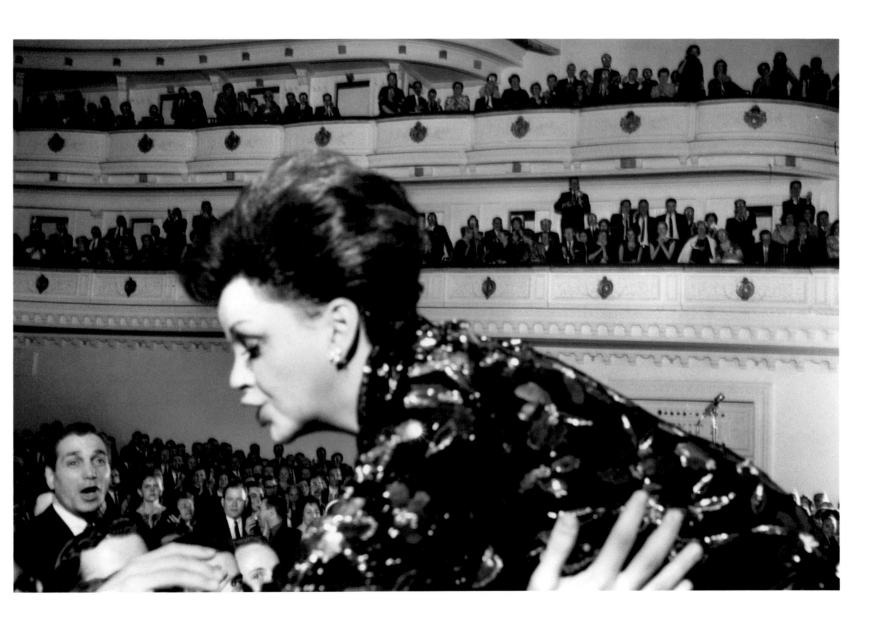

SENATOR EDWARD KENNEDY, 1969

Senator Edward Kennedy was still the heir apparent to the Presidency of the United States. I had been working on a story about him for a number of weeks before he drove his car off a bridge on Martha's Vineyard and the woman with him in the car, Mary Jo Kopechne, drowned. There was no question in my mind that I should photograph the Senator on his first public appearance after the accident. Everyone had questions. I wanted to look him in the face, to record how he looked, and to let the viewer draw whatever conclusions he could.

Miss Kopechne's funeral was different from the other public events I'd attended with Kennedy. This time my pictures would be looked at, good or not. Of course, there was competition and we all tried to guess where the best position would be. My guess? Opposite the bulk of the press, behind the car as it drove up to the church. Richard Drayne, Kennedy's press secretary, seemed helpful as ever and told me the Senator would ride in the front passenger seat as usual.

I wanted to show more than Kennedy's face. I wanted to show where he was. Since I was on the less crowded side when the car arrived, I could choose my position without too much hassle. My luck was that Kennedy was courteous and turned as he got out to open the door for those sitting in the back. As he did, with his collar proclaiming a neck injury and an expectant crowd behind him, a moment that might be a footnote to a footnote in the history of the United States came together in my camera.

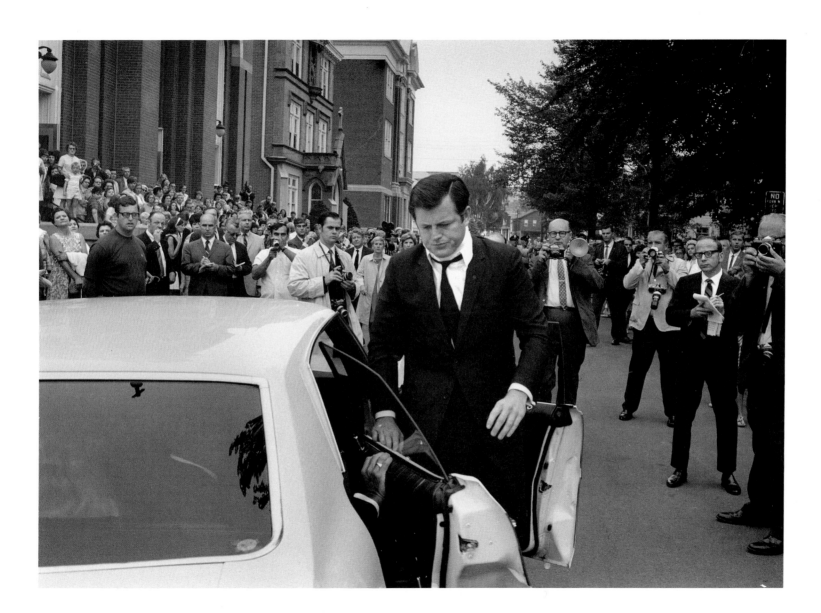

HAPPENING IN PARIS, 1966

Happenings were in vogue in the 1960s and this one in Paris was on the cutting edge of the avant-garde. It had the usual things: A tunnel entrance through creepy stuff, the separation of the audience by sex, attempts to increase the sensual awareness of those attending, and tension. The violinist drew the violin back, back, back as the audience anticipated its destruction. Then the lights went out.

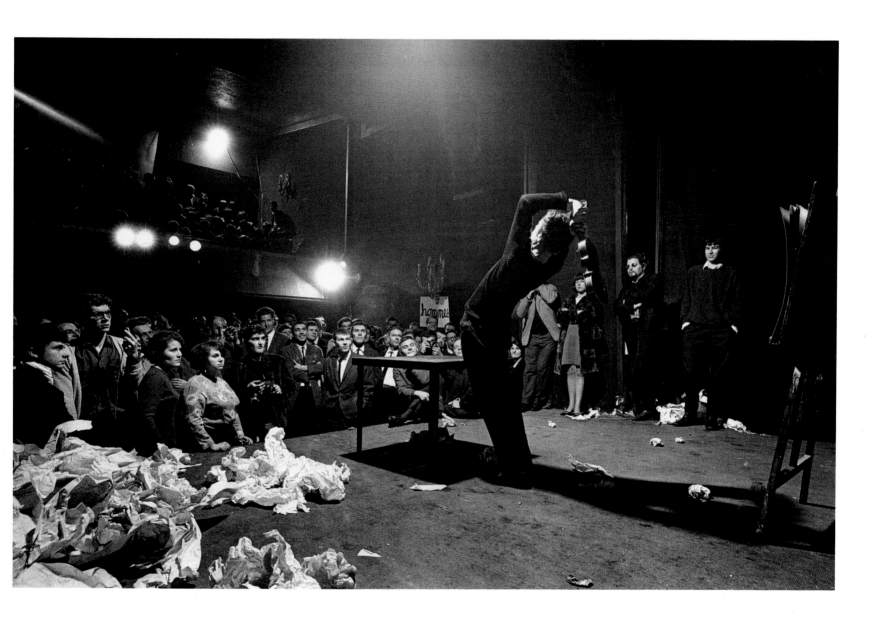

LOUIS ARMSTRONG'S PERFORMANCE, 1965

It is difficult to get the performer and the audience in a single picture. He's in the spotlight, they're in the dark. He faces one way, they face another. I had spent a week in Europe with Louis Armstrong trying (among other things) to solve that problem, but it was not until we got to Atlantic City that I did. The audience at the Steel Pier stood right up to the edge of the stage, so they were as close to Armstrong as an audience could be. I put two or three flash lights up in the rear of the room to light patches of the audience and one over the stage to light the performers and those in front.

Knowing Armstrong's routine well, I sat beside the drummer and waited for Armstrong to sing "Hello Dolly!" In that number I expected he'd joke and spin around, which would solve my problem, but just as important, by then the audience would be happy, clapping, beaming proof of Armstrong's genius as an entertainer.

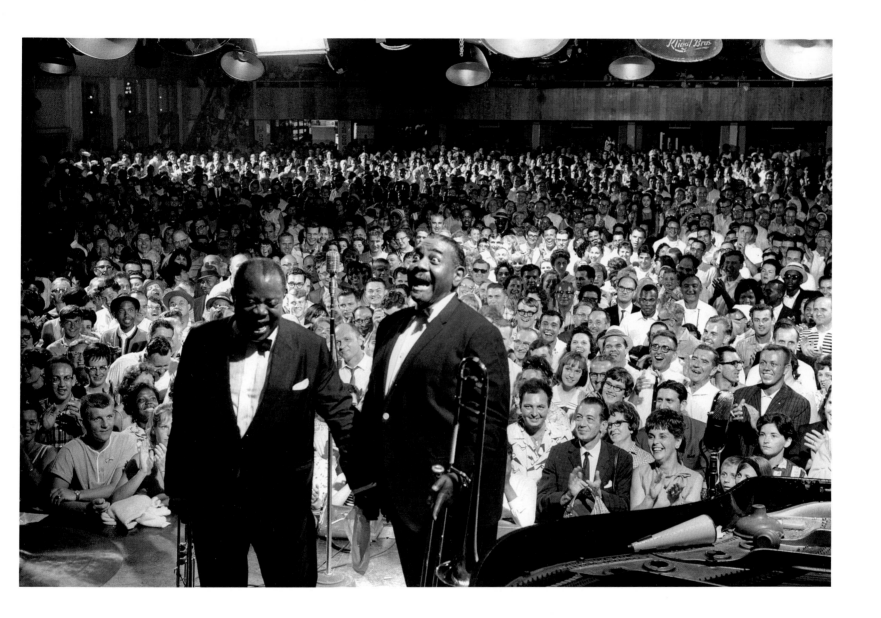

DRUM MAJORETTE AT HALF TIME, 1969

If I said I knew exactly what this picture would look like when I took it, I'd be lying. Too much is happening for everything to be tracked at once by eye. I knew the framework: A drum majorette was very close to the camera and self-involved, doing her number with a baton. In the background, sharp in the sunlight, are spectators from the University of Southern California. I have placed the girl where she is in the picture, but I'm not watching the position of the baton (it's behind her back); I'm watching the shape of her body as she twists to catch it. I knew I'd caught some form and tension, but I had to wait to see the picture developed before I could have more than just a hope that it had worked.

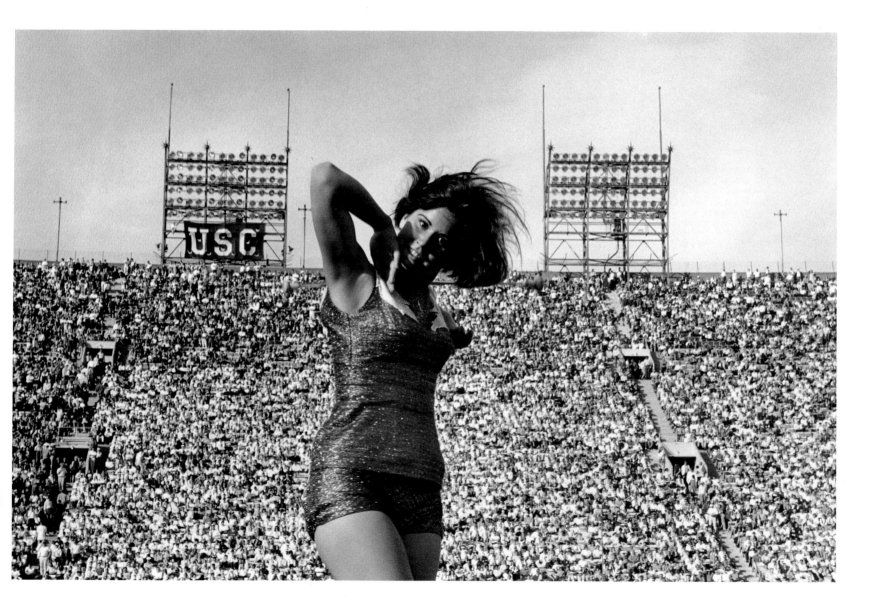

ANNA, 1975

Dinner table conversation about photography changes from year to year, so that what is on everyone's mind now is different from 1973. That was the year I started teaching, when Diane Arbus's work was having its first success and photographic galleries were springing up from nowhere. At the time I wondered if all photography would become not only self-expressive but self-conscious as well. It didn't. Photographers may be concerned, conceptual, confrontational, candid, casual, constructing, but what is important is that they have a point of view.

When I teach a class I often give the assignment: "Photograph someone you love." I ask people to do this so they have a subject about whom they have feelings, a subject that is more than a model, or an object, or a shape, or an idea. In this way, they can judge the result not only by its technical success, but also by how well it describes their feelings. Having asked some students to do this in 1975, I thought it was time to put up or shut up. I took on the assignment too, and asked my younger daughter, Anna, to pose quietly in the afternoon light against the dining-room door, which she did with enthusiasm. She's never been lovelier.

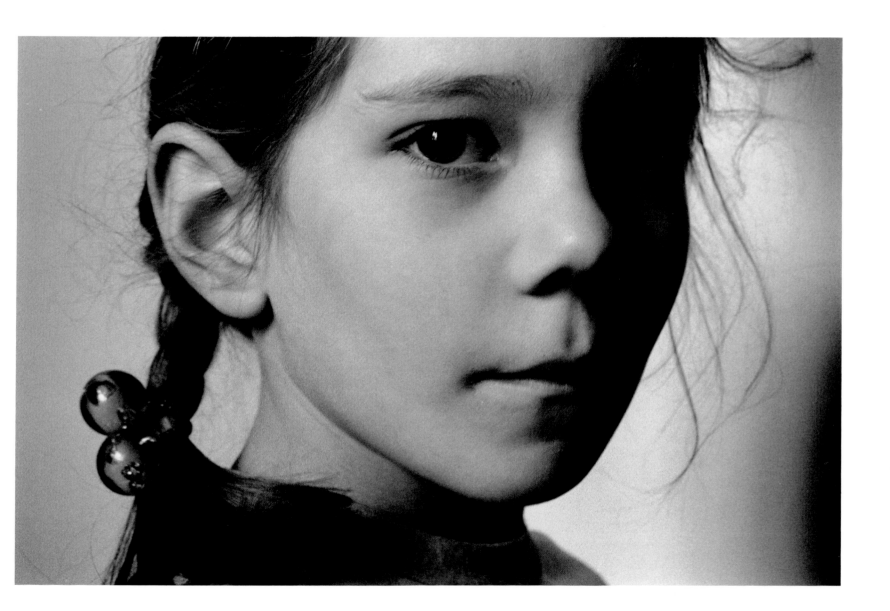

CHILDRENS' DRESS UP, WOOLWICH, MAINE, 1976

We were away from our house in Maine and Robert and Christina Snyder, parents of the two girls in the center, stayed in our house and took care of all our children. When we got back, the girls decided to dress up from the old clothes bag.

I did not want to photograph the children simply to have a record of the way they dressed. They looked like quaint, small figures from an earlier century, and I wanted to photograph our familiar landscape altered by their imagination.

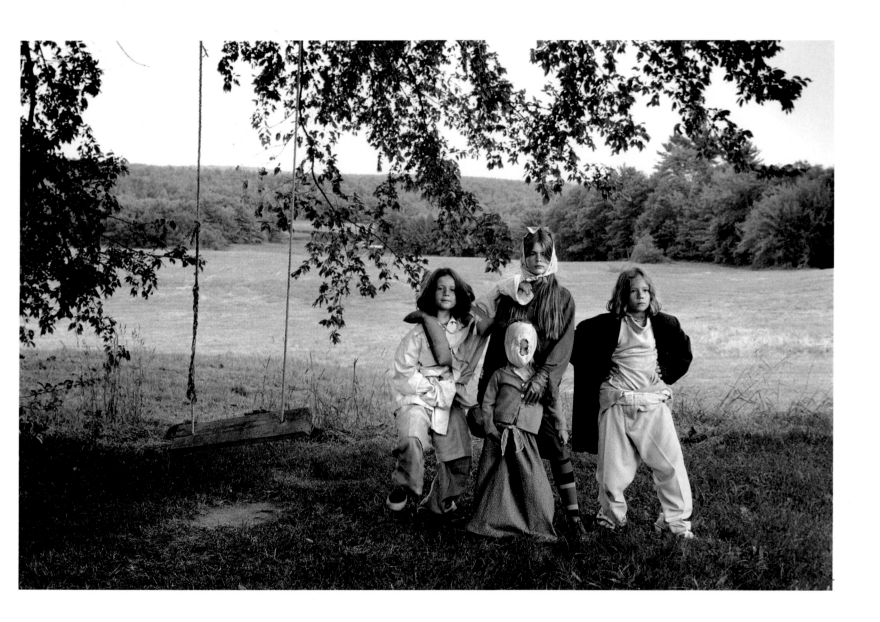

DOLL, 1972

One year *Life* asked a number of photographers to photograph a doll for Christmas. Bill Brandt in England sent in two pictures of a large black doll surreally sitting in his parlor; Elliott Erwitt did Raggedy Ann and Andy at the supper table; Hiro chopped off strands of his own hair to give his bald doll a whimsically distraught look; I simply took a large-as-life example out of the Pryor International Doll Library in Greenwich, Connecticut, and set it under an arbor beside the converted barn where it was housed.

BETTY BLYTHE, 1969

At one time I thought it was better not to pose a picture. I liked the idea that the eye searched events for form, using nothing so crude as the voice (Would you sit here?) or the personality (Lovely, lovely!) to get a picture. A photograph formed only by the eye seemed on a higher intellectual plane than one the photographer influenced.

But while I sat waiting with my candid camera, I noticed that if the subject were to sit in one chair where the light was good and the background clear, I'd probably get a picture, but if he sat in another chair with the bad light and the busy background, I might as well go home. Was it an intellectual crime, I wondered, to ask him to sit in the chair where I might get a picture?

I also noticed that posed pictures can look unposed and unposed pictures can look posed. Now, if there really is a value to unposed photography but you can't know by looking that it is unposed, a photographer would have to go out with a certified public accountant to stamp each frame "Untouched by photographer—Adam Smith C.P.A." That way we'd know which is which. Clearly the idea is absurd.

So I returned to posing when I wanted. When you pose a picture, the problem is to keep it from showing. How can you direct a picture so that it still looks as if it were taken in the third person (Subject unaware of the camera) rather than the first person (Look at me, I'm having my picture taken)?

I think it is best if you keep your directions simple. If a dog can understand it, it's good. (Sit. Lie down. Whatever.) If you ask for more complicated things (Would you lie down on the couch with your head over the edge and your left leg up in the air with your toes curled), you'll probably get the savoir faire and nonchalance we all try to muster when the doctor wants to take x-rays.

I first saw Betty Blythe, who played the first Queen of Sheba in the movies, in the dining room at the motion picture industry home for the aged in Los Angeles. I asked if I could photograph her. She was moving or her apartment was being painted, I've forgotten which, so her mementos were out on the floor. I arranged the chair in the light I liked and rearranged the pictures a bit. This picture was caught on the fly as she talked. So it's fifty-percent posed and fifty-percent candid, and I think that's just dandy.

MARGARET MEAD, 1968

Margaret Mead had an office in one of the turrets of the American Museum of Natural History in New York City. To me, a born New Yorker, it was a welcome chance to visit her and see the inside of one of these curious landmarks. Once up inside, I wanted to include a sense of the outside in the picture. I put a strong bulb in her ceiling lamp to balance the light level so I could see detail through the window as well as in the office.

Although she was kind to me I did not respond to Dr. Mead very much. Usually the people I meet for *Life* are accomplished and I like them, but I thought she was a little hollow. I was surprised. I liked her room though. I liked the fact that a busy woman had all those books and papers in this turret, but I did not want to make her my subject. I wanted to keep her an occupant of the room as impersonal as the address on junk mail, and make my picture a photograph of a place, not a person.

T. S. ELIOT, 1956

T. S. Eliot came to Harvard to lecture and I went over to photograph him for the *Harvard Crimson*, the student daily newspaper. He was in the living room of a friend's house and behaved in the shy, thoughtful manner for which he was known. Even then, I was used to photographing famous people. There was more interest in this Thomas Eliot, say, than in any of the Thomas Eliots living in Boston at the time, so I thought it natural that I'd photograph him. I'm happy to take a picture of a subject everyone wants to see, but I don't want to photograph the famous person's reputation. ("Mr. Eliot would you come over here and write something, please.") Of course, it might have been fun to have asked him to go out to the badlands of North Dakota or the Mojave Desert or some other wasteland, but that was far beyond the *Crimson*'s budget. What usually interests me is having a chance to look at someone and pick out what's interesting at that moment. By far the liveliest frame came when Eliot tried to clarify a point he was making. It was on the front page of the paper the next day, but as usual with a well-known subject, I have no idea if he saw it or liked it.

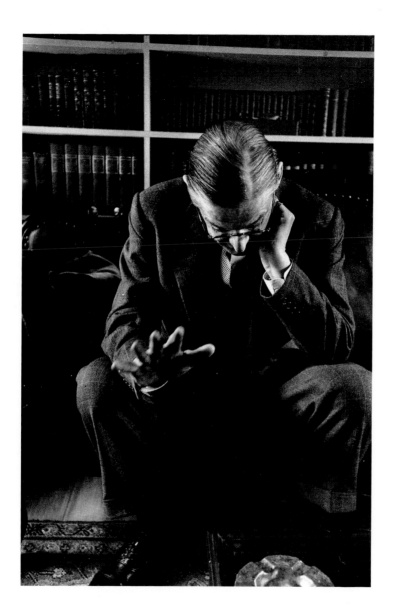

BERENICE ABBOTT, 1981

I was doing a story on six great photographers born in the nineteenth century. Berenice Abbott was not happy at the prospect of being photographed for it. She would only see me for a couple of hours at her home north of Bangor, Maine. She had guests coming. She did not feel well. She did not think our story was all that important.

We met at her house by a lake where she lived in winter. We chatted, and I tried to take some pictures at the shore. She seemed a bit frail and, in the October air, needed her overcoat. Wearing it made her look tense and uncomfortable as she sat in the swing chair suspended from a tree. I asked if we could go to the house she used in summer, where her workrooms were. We drove over. We did not light the stove when we arrived, so she kept the overcoat on, but here the coat did not seem in conflict with what she was doing. She sat on a stool in a position strikingly similar to that in which she had posed Eugene Atget—who was also wearing an overcoat—in her 1927 portrait of him. It was she who saved Mr. Atget's photographs of turn-of-the-century Paris, selling them nearly fifty years later to the Museum of Modern Art in New York for a sum she now termed "too small."

She seemed to be enjoying herself, and I enjoyed her company, but I did not press to stay or return. I would have if she had not been so reluctant in the beginning because I wanted a story made up of good pictures of people, not "portraits." I went to see the other five photographers (Brassai, Alfred Eisenstaedt, André Kertesz, Jacques-Henri Lartigue, and James Van Der Zee) on two occasions each or spent enough time in one day for spontaneous pictures to occur. When we finished the story, we had enough variety to give everyone two pages except Miss Abbott, for whom there was only this single portrait. "They always give the boys more space," She grumped to someone on *Life*'s staff after the article came out.

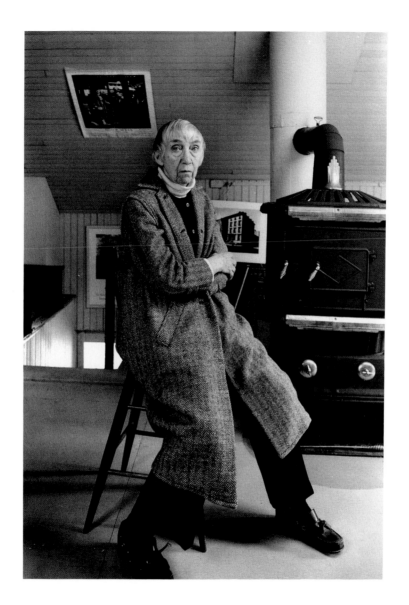

LIZ'S LEGS, 1980

There is no reason why a camera and a pair of legs should make a picture. It's not a picture you can predict, it simply arrives. It's something you notice as you might when someone's foot is tapping under the table. It's an unimportant bit of the scene that, once noticed, becomes the scene itself.

THE BEATLES, 1964

For a while I was famous as the guy who had met the Beatles. They were on their first trip to America and any girl aged twelve wanted to talk to me. "What were they like?" they asked. I said, "Well, you know…okay." Actually, I thought they were four scruffy kids a few years younger than I was, and I didn't know what the fuss was about.

But they were okay. They got in a chilly pool in Miami Beach in the middle of winter and sang when I asked them to because their manager told them *Life*'s cover was important.

The idea of putting them in the pool was mine. *Life*'s bureau in Miami found one where we could close the gate and keep the rest of the press out. The picture was in color. I used a Rolleiflex and a big strobe to put light in their faces. I worked like a cover photographer is supposed to: I had my idea; I got the subject to do it; I lit it; and I recorded it. That kind of precision is fun when it's an idea, but it seems too premeditated to me when I'm photographing. I get flustered and can't remember how things are supposed to go. That's why the Beatles are spaced unevenly. If they formed a wider group, the diving board would fit into the composition. I like having ideas beforehand about what I might do with a subject because that gives me a point of view, but then I want to respond to the situation as it is, without adhering to a fixed plan.

If the pool had been heated, we'd have spent more time, but there was no point in cajoling four goose-pimpled kids further. They got out, nibbled some bagels and lox, chatted with the owner of the pool, and left.

Life's Managing Editor was on vacation that week and I was told that the Editor-in-Chief who took his place did not think the Beatles were serious enough for a cover. At any rate, he ran it in black and white on the last page of the magazine. Since then, all the color transparencies have disappeared from the files and only a black-and-white copy negative remains.

The color ran once, on the cover of a German magazine that had rights to use it. That helped save my reputation. The Beatles naturally asked, "Why no cover?"

"Oh, the photographer messed up the color," the *Life* reporter who had been with me told them when they met in London a few weeks later. "He did, eh? How 'bout this?" they asked, holding up a copy of that week's *Stern*.

Twenty years later, to mark the anniversary of the Beatles' arrival in this country, we made a black-and-white print and had it colored by hand (it may look better than the original did). We ran it on the cover of *Life* where, I confess, it looked serious enough to me.

BOY AT ETON, 1968

I've watched as my three children were born and I felt their personalities as clearly as they entered the world as I would now as they enter a room. I take children's faces seriously. This boy at England's prestigious school, Eton, was one of the few willing to face a press photographer on Visitor's Day. What is he doing now, nearly twenty years later? A psychiatrist? Civil Servant? Managing Director of a baby food company? Master scribbage player? I don't know, but I'm sure I'd recognize him if he came through the door.

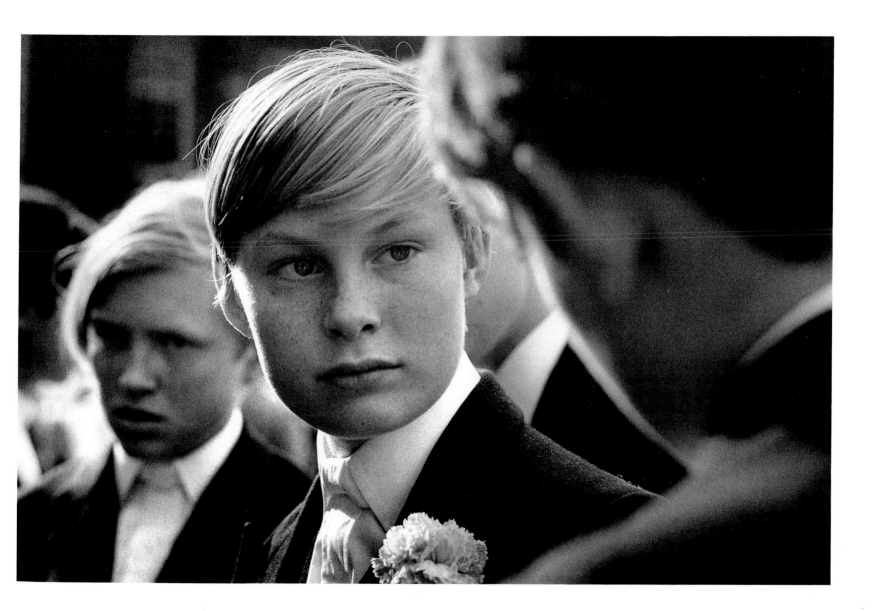

BOY IN MANCHESTER, ENGLAND, 1968

The boy's face supplies enough pictorial content for a dozen pictures. I noticed how the street receded behind him and framed his head. I was happy when he turned to listen to his mother's shout from down the block, but it's his buttons that really count. I hadn't time to examine them or the wrinkles in his shirt before I was taking pictures, but the shirt's disorder, I knew, would balance the sweet, too-perfect look that nature had put upon his face.

MICHAEL AND DAVID PALMER, 1978

Half the photographs in this book are of photographers, painters, writers, or musicians and that's not surprising. Artists make good subjects. They look as they look, not as they think other people think they should look, and they are usually sympathetic to someone who's trying to take their picture. I certainly have had more success with them than I have had with the actors, politicians, athletes, and businessmen who are also common subjects for journalists. It may go deeper: I'm more interested in what artists do and that interest translates into a point of view that probably makes me more interesting to them and therefore they are more interesting to the camera. (Who said photography was simple?) If I knew more about finance (or bridge) I might have taken an even better picture of Jack Dreyfus who started the Dreyfus Fund than I did; and if I knew more about precinct politics, I might have made a classic picture of Ronald Reagan when he campaigned for the nomination for Governor of California.

I did not grow up thinking I was an artist at all, and it was only in college that I realized that I had been solving problems as a photographer that were similar to those with which writers and painters grappled. I was glad to find that others shared these questions, but I never thought it gave us a special place in the world. Still it's nice to do a story on someone who worries about how things will sound or look beneath the surface as well as upon it.

In Wichita, I asked Michael Palmer, music director of that city's Symphony, to sit on a couch and let his son David join him. They chatted brightly until there was a pause in their togetherness.

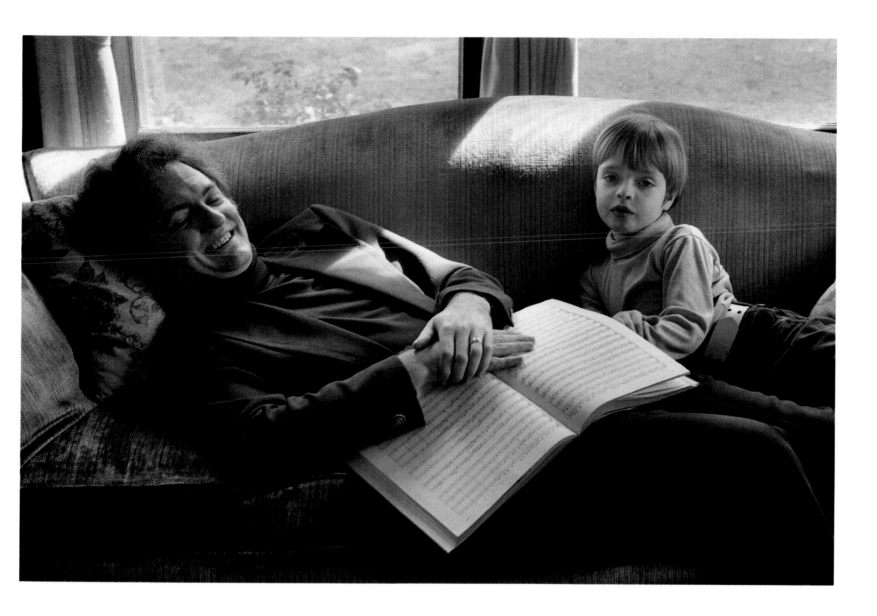

JOSEPH PAPP, 1986

I felt as I had in 1964 in Addis Ababa when I left the airport before the arrival ceremony in order to find a spot to photograph the carriage carrying the Queen of England and Haile Selassie through town. There were crowds, but the carriage was closed so I could not see the occupants. There was no picture. I had come several thousand miles and made a dumb decision. I thought none of my colleagues would have been so stupid—Leonard McCombe would have gotten a picture; George Silk for sure. I thought I was too inexperienced to be doing this work. I wished I'd never come.

I got my pictures of royalty later on the trip, of course, but the same desperate feeling came over me in lower Manhattan in 1986 as I stood in the office of theater producer Joe Papp. He had only ten minutes to give me, and I wanted to leave. I had already used up half my time trying to figure out how to make a picture. He was trying to be helpful, but I couldn't see anything unusual to do. I stood there thinking I needed a gimmick, but I don't like gimmicks. Someone who likes gimmicks should have been taking this picture.

I didn't want to mix him with the posters on the wall. That's what people always do. I wanted to come close in on him, but because he was mercilessly aware of being photographed, he'd have looked stiff. The camera was on a tripod beside his desk—not too close, about where you'd sit for an intimate chat. The light was right. Suddenly he leaned forward, filling the frame entirely.

"I can put my chin like this. You like it?" Click, click, click. Terrific. That's perfect!

"Why do I always have to show them how to take their pictures?" he asked his assistant as I packed up and left the room.

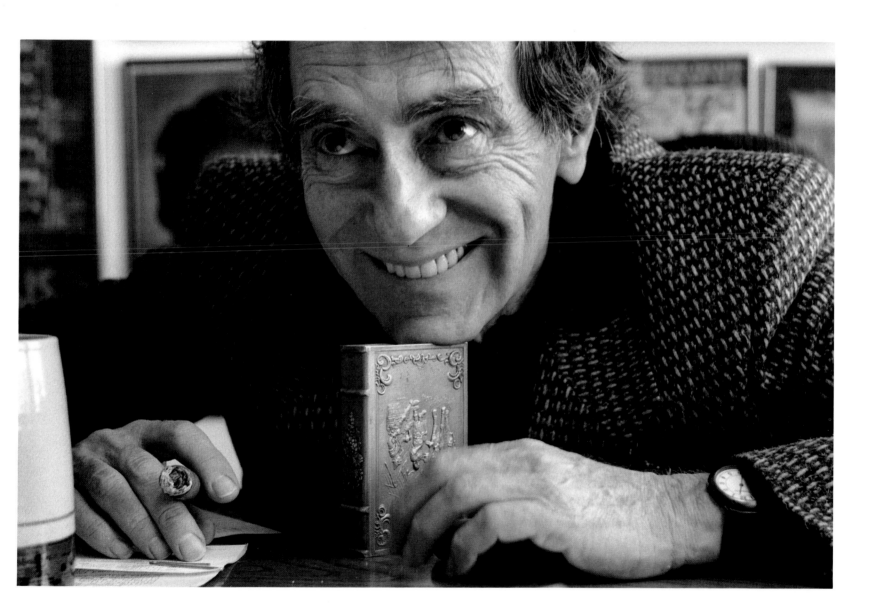

KID THOMAS VALENTINE, 1972

I took this photograph of the jazz musician Kid
Thomas Valentine at his home in New Orleans
the day before the Picture Editor of *Life* called
to say that the magazine was going out of busi-
ness. It was only "suspending publication,"
they said, but nobody believed that. The last
thing I imagined at the time was that I'd be
one of the half-dozen staff members who'd
never leave and after five years be "instrumen-
tal" (as the press release put it) in *Life*'s rebirth
as a monthly.

The announcement I heard in New
Orleans was not unexpected—working on the
magazine for the last few years had been like
living with a fine person who had a serious
illness, but still you don't know quite what to
do. First question: Should I finish photograph-
ing Kid Thomas? I had said I'd be at Preserva-
tion Hall to photograph as he played that
night. The answer? Sure. The important thing
was taking pictures, not whether there was a
magazine to put them in.

J. R. R. TOLKIEN, 1968

I took Professor and Mrs. Tolkien to lunch in the dining room of the seaside hotel where they vacationed. A baby started to cry and the Tolkiens said they did not think babies should be allowed in the dining room. They had done their share, they felt, and deserved peace and quiet. I had two young children at home then and understood their point. What surprised me was that they'd make it in front of a journalist. I don't think any writer in America would let himself seem so stuffy. Hate kids? Wow!

But Tolkien was an English don, and if he weren't a bit stuffy about having his picture taken it would have been taken often and I wouldn't have come there to do it. All through my lunch my great worry was not to let on I had not read *The Hobbit*, or worse, that I'd tried and did not like it.

However, he was much too polite to talk about his work without my bringing it up, and I chose to seem much too polite to bring it up unless he did, so we got along fine. Actually, he probably sensed my ignorance. I should have worried about the picture more, because after lunch it seemed understood that we'd adjourn to his workroom for the photographic session and that would be it. The room was on the top floor, under the eaves where he'd placed a card table and a chair. I'd not laid the groundwork for a more interesting location—their bedroom on another floor might have had better light—and it seemed too late to start pressing such a private personage. All that I could make work in the attic was this basic headshot as you'd see it on a coin. If Hobbits were to use money, maybe it would look like this.

ALFRED EISENSTAEDT, 1981

If Alfred Eisenstaedt were seven feet tall instead of a bit over five, he'd look like this but he might not be the great photographer he is. His stature gives him a good vantage point from which to make the quick, eye-level pictures he is famous for. I am several inches taller, at six feet. When I use the camera at my eye level I have to point it down most of the time, which, if you think about it, is not always a pleasing way to look at people. Therefore, I long ago bought a device called a "waist-level finder" for my camera, which allows me to look down to see the picture on the ground-glass as I hold the machine someplace between my chest and my toes. It is then comfortable to hold the camera three feet off the ground, whereas if I needed to look through it with my eye straight ahead, I'd be on my knees or bent over like a pretzel. I used this device to look up into Mr. Eisenstaedt's face.

A photographer has a problem taking a picture of someone walking. You run ahead, turn, and snap. Then you run ahead, turn, and snap again. It's good exercise but each time the background changes and you only have an instant to compose. Mr. Eisenstaedt showed me a trick. Actually he was trying to tell me what picture I should take, but it is a nifty scheme, and I'll use it some day with success. "Take a stick," he told me, "and put it down on the ground. Focus on it and ask the subject to walk in a big circle. Tell him every time he crosses the stick you'll take his picture." He demonstrated, but I liked the picture done with my trick better than the one with his.

GEORGE NAKASHIMA, 1969

You can't be too rich or too thin. Photographers add: You can't be too close. Robert Capa, the war photographer, commented that if your pictures weren't good, you weren't close enough and that's true in peacetime, too.

This picture is taken just outside the kissing range. If I were any closer, I'd be in George Nakashima's "personal space," too close for him to feel comfortable. Different societies apparently have different distances closer than which it's improper to come. Ours seems to be about thirty inches (some Arabs are said to have less) and at two-and-a-half-feet, a 65mm lens fills the frame with a person's face. The 65mm lens I use was made for a device that converted rangefinder Leica cameras into single lens reflexes (this was the shortest focal length that could fit) and with this perspective the features stay pleasantly rounded. A shorter lens used at a closer distance shows us a perspective we don't like, where the nose starts to loom forward and the forehead begins to bend away into the next county. (When you kiss, if you keep one eye open and think about what you see, you'll see the same perspective as you would with a 35mm lens.) Longer lenses provide the perspective of a face we see across a table, or across a room, or across a street, depending on the length of the lens. The features of the face flatten out, which often increases the face's graphic impact, but we lose the feeling of intimacy we have when we see the features in the round.

BUCKMINSTER FULLER, 1970

I thought the only thing I could contribute to history and humanity was to show what Buckminster Fuller looked like behind his glasses. I'm not sure this picture does it, because the contrasty light may distort things. But whenever I think I have really distorted a subject and I get a chance to go back and look, I discover: "My God! He looks just like his photograph!"

He was a charming man and talked so much you got more sense of spontaneity than actually existed. I liked him very much as a person, but his glasses formed a reflecting mask. When I visited his family's island in Maine, I asked him to sit in a corner between two windows and let the light play on his face. One window lit the back of his head and the other lit the front. In between, the exposure fell off to nothing. He wore gauze on both his ears to pad his hearing aids. I liked splitting his head this way, making it so long and large that you become aware of the distance from the San Francisco of his hair to the Boston of his nose. I like it because we are used to thinking of the head as a round-ish egg shape. Of course, I came to this angle because it was the only way I could get behind the glasses.

He had many guests, acolytes, and disciples visiting with him on the island, which he shared with his sister and other members of his family. Every night at dinner, the family sat at their table in the dining building and the rest of us sat at Fuller's table as he continued pontificating into the night in a fashion that existed in the late 1960s and early 1970s and seems to have floated off the earth since. He had never completed a dome on the island. His friends and neighbors on Penobscott Bay said they did not want to see white, golfball-like domes sprouting up among the pines on shore. He wondered why, since they all loved lighthouses, which are white and nearly identical to one another too.

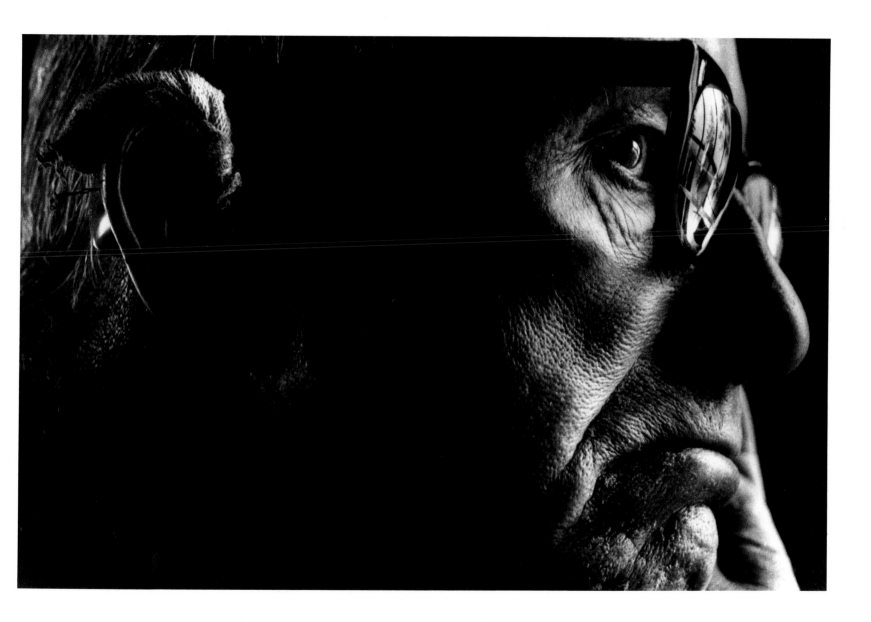

LOUIS ARMSTRONG, 1965

Louis Armstrong applied balm to his lips every night after a performance. Richard Merryman, a *Life* editor, wanted me to photograph the ritual. What in heaven's name do you do to make someone interesting when they are putting cream on their lips? I set up two small strobes on either side of the dressing table in Las Vegas to give me lots of light and complete sharpness from foreground to background. I used a Polaroid camera with a conventional shutter (like the one on my camera) as an exposure meter and for a lighting test. Then I moved in very close and took a dozen frames, all this tight, as the fingers moved over the lips, working the stuff in. I didn't use another vantage point because I thought this looked exciting. I sent the assistant off to Los Angeles to process the film and bring back a contact sheet so we'd know for sure that we had it. When he returned I was very proud to see that I had made two fingers and a lip so strong they could be anonymous.

BRASSAÏ'S EYE, 1981

My lens is only a few inches from the face of the photographer Brassaï. My fingers are around the barrel, focusing. His hand comes up, and he mimics my motion. Quick as a flash—click, click, click. I tell him that was terrific. Marvelous. Can you do it again? I'd come to the end of a roll of film. I wasn't sure I had the picture. I change film. He repeats the gesture. We try for a whole roll, but something is missing.

When I look at the contact sheet I see I got the picture on that first exposure. Great! Then when we went back, trying to repeat or improve on it, the psychology is missing. That first time it was his idea, his action, his desire to make a comment. There's tension in the muscles of the eye and fingers. When we repeat it, it's my idea. He is trying to be helpful, but he's just following instructions. Different muscles are working. They don't have tension.

In reality, it was a shy, amusing thing for him to do. It said, "Why are you staring at me? Is it worth it? Oh, goodness! You're close!" What I like about the picture is that it is a very candid photograph that records a small event; and yet it is also a landscape with contours, holes, hills, pools, valleys, and action. Later, he asked if he might send it to people when they asked for his portrait.

BRASSAI'S MASK, 1981

I try to stay easily bored. I was bored when we met the photographer Brassai in his apartment. There were three of us from *Life* and with his wife that meant five people were edging around the small rooms. The walls were cluttered, and the light was wrong. It's easy to become enthusiastic and "make the best of it." I didn't want to, so I asked the usual question: "What do you do in the day?" He answered, "Go to my studio." "Where?" "A few blocks." "Let's go." Anything was better than the apartment. (Understand it was a nice place to live, just not to photograph.)

The light in the studio came in from the door and there was a bulb in the ceiling. The room was filled with statues, paintings, photographs of graffiti, boxes, and God knows what else. After the desert of the apartment, this room filled with visual material left me overwhelmed. I went from feeling starved to being confronted with my third helping of cake. Perversity entered. I told myself that this was nice, but I don't want to just show niceness. What can I take that isn't "nice"? I waited. I let it look as if I was bored. Unimpressed. Unhappy. The bull's head was his idea. I would never have suggested that he do this.

There's nothing particularly interesting about a man picking up a bull's head made of wicker and holding it as a mask in front of his face. Imagine sitting in someone's living room and so-and-so, the life of the party, just back from Spain, pretends he's a bull. You pretend you're amused. But in this case there is a certain interest. Because of what's on the wall. Because of what's on the ground. There are photographs on the wall in two dimension and in this photograph Mr. Brassai is, of course, in two dimensions too. With the bull's head he starts to resemble the art in the room.

The woman in the photograph to his right he referred to as his Mona Lisa. He said "Where's my Mona Lisa? Oh, here she is." And he took her out and showed her to me. When you are lucky and God is on your side, as you always hope he is, so many little things start coming to your aid. A small thing: That his body mocks her body and pose is something I did not notice and he certainly did not think of doing. Nobody thought about it and yet it is one of the things that holds the picture together. When people see you are bored, they start to do things. Boredom is not necessarily boring.

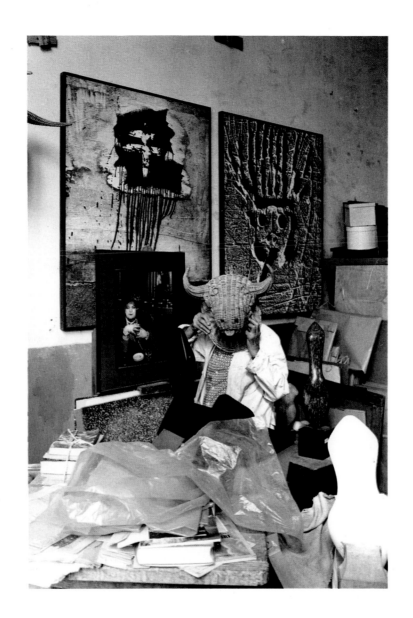

FRANK SPENCER, 1978

Radio City Music Hall was on the verge of going out of business in 1978 when I took this picture for a possible story in the dummy of the monthly *Life*. I went upstairs in the Music Hall where they had a replica of the stage and auditorium that was used by set and costume designers to see the stage from the point of view of the audience.

I happened to take a light with me. I rarely do this because usually a window will give me the kind of light I want—light with direction. The amount of light isn't usually important as I can always use long exposures. It is important, though, that the light be coming from some source, not bouncing all around, off the floor, walls, and ceiling.

I knew there'd be a lot of lights around the Music Hall, because it's a theatrical place, but I wasn't sure what type. I'd looked at the Rockette's practice room and it had flourescent lights and mirrors and was very dull. I thought I might need a light to add directional punch if Mr. Spencer was in the same kind of room. He was. I plugged in the light on the left.

This is a standard photographic illustration: A man, the tools of his trade, and the place where he works. What makes it a little different is that he wears a mask. I can't remember how it came about. I think he did it for a second as a joke, and I said, "No. No. Keep it. That's wonderful."

What I fear as a photographer is that I am just going to record what is there. Actually I don't do that particularly well. If you want a clear record or a depiction or a report of something, I'm not very good. I keep looking for tension.

The mask gives mystery to the picture. While you can't see all of his face, the mask is revealing of his character. It both hides and reveals. Because his features are kept out of view, the gesture of his body and arm is emphasized. And because it is impossible to see his face, you have to look elsewhere for evidence of character. His body conveys the sense of his spirit. The mask separates the tools of his trade from the place of his trade. Without the mask, this would be a dull picture.

Photographing someone is like playing the Scottish game of curling, which is played on a rink like one for hockey with large granite stones and brooms. It is a strange game. You walk in front of the stone, sweeping the ice with the broom, forming a path for the gliding stone. The swept ice leads the stone. To tell the truth I've never played it, and I don't know how it's done. But it looks like what I feel I'm doing when I photograph. I am agreeable. I don't project my personality on the subject, because I don't want only to photograph his reaction to me. But at the same time, I have to draw him out. Lead him. Sweep the ice and

make him follow the path I've brushed. At the slightest sign of anger or impatience, it's sweep, sweep, sweep, and smooth it out.

People can't stay self-conscious long in front of the camera unless they are celebrities used to constant public gaze. Real people get bored. Boredom in a subject can be a photographer's ally. When I bore you, you stop trying to impress me. You begin to be yourself, and I may want that to happen.

I often don't know my subject. It's like going into a shop to buy something. I don't know the salesperson, but we both know our roles. My subject shows me his wares. I appreciate this and show it by taking pictures. Our relationship is not deep. I trust he is what he is supposed to be. In this case, I respect Radio City Music Hall. It is an old institution and he is part of it. I can tell that he is well thought-of, and I can admire his work. I don't need to go into detail about his character and position in society or the role of Radio City Music Hall in Western culture. That doesn't interest me. I think he is a good man and a good man is enough of a subject for a picture.

We had an appointment at ten o'clock and I knew that I would be out by eleven. I left the Music Hall and crossed the street back to my office with a good feeling, a sense that there had been a tension in the picture, and that something had been out of the ordinary.

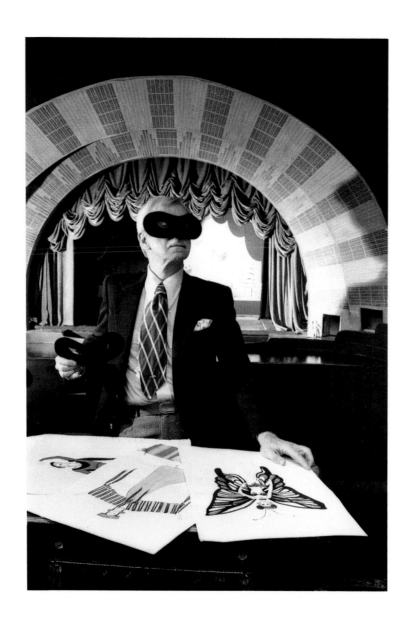

SNEAKERS, 1977

Sneakers the cat was one year old and my daughter Anna was eight and a half. You can tell because no cat would take this mauling from an adult. A cat born into a household with young children believes that existence includes being manhandled and shaped into human poses.

It is not easy to make a cat look silly, but the world's most graceful animal became awkward, ungainly, and uncoordinated at the whim of a child. A jumble of limbs. A mess of parts. Unnatural. Anti-order. I love it.

SAN FRANCISCO MIME TROUPE, 1969

I was going around California photographing what was new and the mime troupe in San Francisco that performed in public parks was getting wonderful reviews. However, they weren't giving performances while I was there, so I never saw what they really did. But for a photograph they were willing to get into costume and go up to the roof of the building where they were headquartered to pose for me. His gesture with the tongue was something he'd done spontaneously downstairs in the dressing room, and I suggested he redo it here for its startling effect.

BILL COSBY, 1969

Photographically speaking, there are advantages in being dark. One of them is that you can be the subject of a picture like this. I had wanted to take it all spring after noticing the sunlight on some whitewashed walls in California. When I exposed the wall instead of the skin as the middle tone, the detail of the skin would drop out and I'd have a surprising, casual silhouette. I tried with black activist Ron Karenga, who was an unwilling subject, and Howard Bingham, a young photographer working for *Life*, who was bashful. The results were promising. The silhouette is a strong shape in contrast with the wall, but there was no action.

When I went to Bill Cosby's house in Beverly Hills one Saturday morning to take his portrait, I found him grumpy and sleepy. We tried a picture inside, but clearly there was not much enthusiasm on his part. I suggested that we move out by the patio wall, and asked his business manager to hold some papers to keep the sun off Cosby's shoulders. In silhouette, with the lips parted, you don't know if the cigar is going in or out. The act of smoking gives the picture a sense of purpose. However, the silhouette, even with the cigar, turned out not to be what director Alfred Hitcock called the "MacGuffin," the necessary object of a chase. It was the wire-framed eyeglasses, wonderfully bright and full of dimension in the middle of the silhouette, that were the secret of the picture I was looking for.

ALLEN GINSBERG, 1966

Allen Ginsberg, the poet, was having tea with students in a small room at the University of Kansas. The sun came in over his shoulder and projected his shadow on clouds of cigarette smoke. I sat on the floor in front of him and played with the notion of how little of his face I needed to show to make a strong portrait.

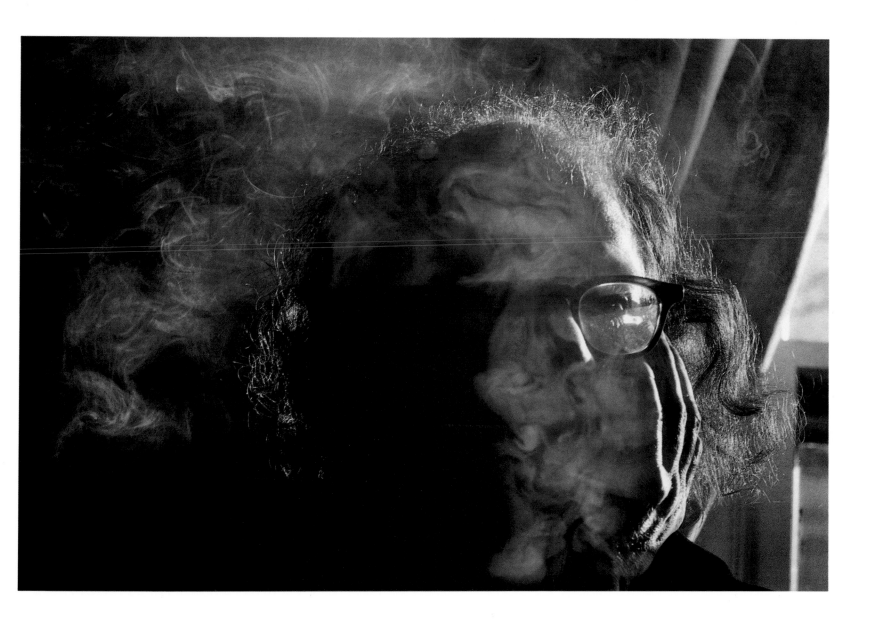

GULFPORT, MISSISSIPPI, 1970

Robert Ajamien, a *Life* editor, passed through Biloxi, Mississippi, six months after Hurricane Camille struck and said, "My God! The devastation is still there! Let's do a story!" I am skeptical when someone, even a *Life* editor, says there are pictures to be made someplace, so I went down doubting there'd be much to photograph. The rule of thumb with storms and other acts of God is that the day after is too late for good pictures. Everything is cleaned up and the drama is gone.

Actually, a lot of houses still stood in the twisted, torn shapes the storm waters created. All the debris was gone. Everything was neat as a pin, yet these homes stood as silent witness to a frightening force. Ajamien was right, of course, but that wasn't all I learned. As I photographed the wall of a shed, I tried to make the twisted clapboards dramatic by using a red filter to produce a black sky on the film, but I realized this wasn't enough. Dramatic as it was, I'd seen something like it before.

What I discovered was the need for *peculiarity* in a photograph. If there is nothing peculiar, don't take your cameras out. You don't need to see a two-headed cow; the peculiarity may be something small, only part of a picture. It may be a cloud, an expression, a shadow, a juxtaposition. It may be the selection, or order, or angle of the picture. However, you have to be able to say it is *peculiar*, not dramatic, or beautiful, or interesting, or historic, although it might be those things, too. A photograph, I realized, needs a dash of *peculiarity* the way a Bloody Mary needs a bit of Tabasco. As soon as I understood this, I could quickly tell which wreckage to photograph.

I had another idea when I first looked at the pictures back in New York. If I returned to the scene and used infra-red film, I could make the foliage around the buildings white and brighten up my pictures, which suffered as a group from the inevitable dull gray fringe of green foliage around each structure. Chlorophyll in plants reflects infra-red light, and on special film they quickly become overexposed. I brought a big, 4×5 inch camera with me, the kind you can stand behind and focus with a cloth over your head. It is something I rarely use, but when you know exactly what you are going to photograph and from where, there is no reason not to use it. I could have used a small camera and infra red, but the small-camera version of the film is very, very grainy and the image becomes soft. The 4×5 is crystal clear. Infra red is a tricky film to handle. Finger prints get on it easily when the film is loaded into holders and there is also no way of being sure exactly what the exposure is. Every time I use infra red I lose a number of exposures. But with this film, a scene that was drab and gray became light and eerie.

Better than any of the houses was this lot where a house had been. You see a tire hanging from a tree ready for a child to swing. You wonder. There is a tense mystery to the photograph. The trees look as if they were dogwood or cherry in blossom. The gate and the path lead to nothing. That is a positive fact, and I can show it. It is also a *peculiarity*.

PIG JAWS, 1983

I spent the morning in the Waipio Valley on Hawaii surrounded by nature, which is a green mess, and I was thirsting for a sign of human order.

All that morning I had pressed David Fujimoto, my guide, to tell me what he thought was unusual to see in the area. "The Black Beach?" he suggested. Well, yeah. Okay. "The little old hotel in the valley?" Hmmm. "Mrs. Duldulao's taro fields?" Yeah. David was feeling a little frustrated when we came up from the valley floor for lunch. "John, there is a guy with pig jaws all over his shed. Is that the kind of thing you're looking for?" I loved it.

The man who killed the wild pigs whose jaws adorn the wall of the shed was not at home. Mrs. Imada said her husband remembered every hunt and where each jaw came from. Calbert, their son, said he could stand on his head, and showed me. I felt like a hunter, too.

Mrs. Imada gave permission to photograph (I was one of fifty photographers working on a book entitled *A Day in the Life of Hawaii*) and young Calbert did his trick because the shed was not enough by itself to make a picture. The boy was not enough with just the shed either. The pig jaws would not be interesting without the boy, and the boy couldn't just stand there looking at the camera. So that's why I asked if he could stand on his head. I got my quarry. This book is my shed.

ELIZABETH KALKHURST, 1985

My daughters spent the summer in France and came back with snapshots of themselves topless on the beach. "Everyone, Dad, is topless in France." I matured.

That autumn, Elizabeth Kalkhurst was happily looking forward to a lunch in the country (I was going to photograph a photographer). The debris of breakfast lay on the counter in the only spot of sunlight that comes into her apartment. I have used it before and it always works well. This is not a nude in the tradition of Western painting or the photographic tradition of Edward Weston and Bill Brandt. It's a nude in the current fashion of American and French beaches, which is to say that another part of the body can be shown casually. A hundred years ago, seeing Miss Kalkhurst's ankle would have been a shock.

ALFRED EISENSTAEDT AT JONES BEACH, NEW YORK, 1981

I don't like people telling me how to take pictures, and I don't like people telling me where to take pictures. However, one can be too rigid about this. I was a teenager on a steamer going to Nantucket Island for vacation with my family. I was standing on the lower deck, looking off to starboard, trying to take pictures of some seagulls when one of the crew shouted, "Hey, kid! Come over here and take a picture!" Fat chance, I thought. But he insisted. What do you do? I figured I had to go. There on the other side of the ship, fast dropping off to the stern, was a schooner under full sail, backlit in the water. It was too late to make a good picture, but if I'd moved earlier, it might have worked. Certainly it was better than the gulls.

So while I still hate it when people say "Hey, mister! Take my picture!" or "John, have you got your camera?" I've learned to listen to suggestions. When the kibitzer is Alfred Eisenstaedt, it just might pay off. "John," he said, "you can take my picture as I stand like this."

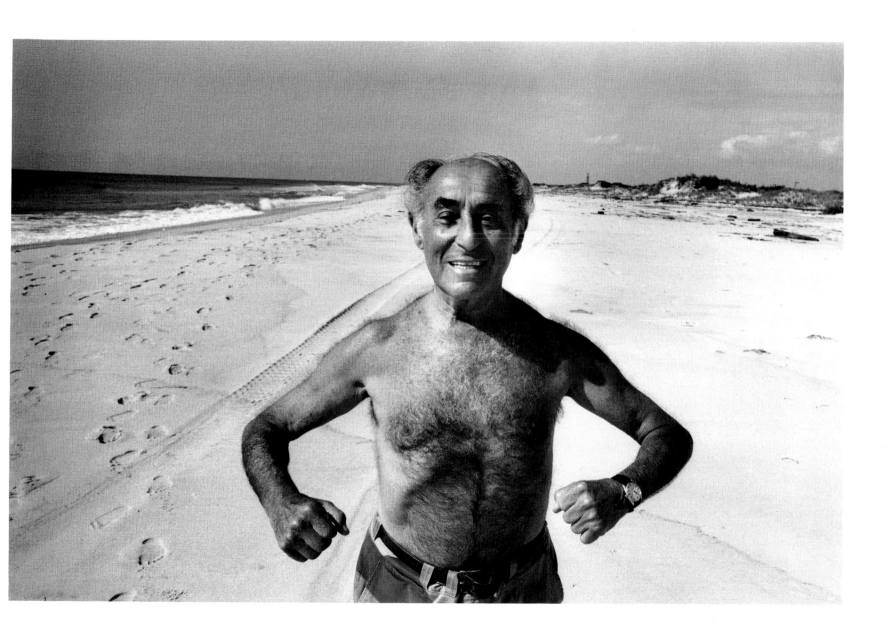

TARO FIELD, HAWAII, 1983

This picture was taken at close to noon, which is a bad time to photograph anything except a taro leaf that is looking up at the sun. At noon, the sun lights the tops of things and I'm usually interested in seeing the sides of things: The face not the scalp; the doorway not the roof; the slope not the peak. Indeed, the hills in the distance suffer in this light and look washed out. But the camera can do one thing the eye can't: It can focus on something close and something far away at the same time and this trick is always pleasing.

FANNIE AND ROMUALDO DULDULAO, HAWAII, 1983

What interested me then and what interests
me now is her hand—the way she pulled him
in to kiss. It was not how I expected her to
kiss or asked her to kiss. It was simply what
she did.

MARK AND LYUDMILLA REDKIN, MOSCOW, 1984

Photographers are a little like family. I spend my days talking with them, and about five years ago I began to photograph them. In 1984 I went to Russia at the urging of the Soviet Embassy in Washington to look through Russian archives of World War II for photographs to use in a special issue *Life* planned for the fortieth anniversary of VE day.

"No, no! Under their beds! That's where the pictures are. You have to go to the photographers," said Felix Rosenthal, a Soviet citizen who's worked for *Life* for the last twenty-five years in Moscow. He was right. Even with an invitation, it took two weeks of daily requests to get into any archive, and when I did it wasn't much use. Under *Tanks*, for instance, were photographs of the famous T-34 from every angle (you could build one in the year 3000 just by studying these pictures), but none in action.

Felix knew from past research that the surviving combat photographers had searched out obscure files that contained their negatives, and had good collections of their own work. He took me to a publishing house where the editor made a phone call. In five minutes Mark Redkin bounced into the room with mock-military jauntiness. As a lieutenant colonel in Berlin in April, 1945, Redkin arranged a photograph of his fellow photographers and correspondants in front of the Reichstag. Now he assembled another group of war photographers for me in Moscow. A few days after the session I went to his apartment. I'd become as interested in photographing the photographers as in collecting their pictures. The story we did mixed both.

The Redkins put caviar, sturgeon, and cheese on the table and offered some fine vodka, but I did not take more than a sip of the alcohol, any more than a baseball player would drink a martini before going up to bat. Photography is athletic. Your emotions have to mesh with reality at all times. Things can always go wrong. If it's not focus, it's exposure. If it's not exposure, it's timing. Each must be exact. Of course, a drink or two is not bad for the subject. It may soften the cold stare of the camera and so, as we talked, Lyudmilla was moved to give her colonel an affectionate hug.

FLORETTE AND JACQUES-HENRI LARTIGUE, 1981

"Hello, what would you like me to do?" The first thing I asked was if he would sit in a chair by the window. Nice, but static. I looked at the table and asked if he worked there. "Yes, yes." He and Florette were working on diaries there. "Mr. Lartigue, would you like to sit there?" "*Bien sûr.*" He spoke French and I spoke English and Judy Fayard, *Life*'s European Editor, translated. I moved the tripod over and made a few exposures.

When I was growing up, people went to photographer's studios to have their portraits taken and the question was: Should it be serious or smiling? The photographer Brassai wrote that for him only a serious expression in a portrait let you read the character of a sitter. The consensus in my family was that smiling portraits "didn't last."

Before 1980, I usually stopped taking pictures when a subject smiled and rarely photographed someone laughing. Since then I never stop. I don't tell jokes. I just mumble something like, "That looks pretty silly!" and people giggle. They are posed. They are nervous. They are trying to please. They want release. They laugh easily.

In Moscow when I took a photograph of the Russian photojournalist, Mark Redkin, and wife, I had to worry when they laughed because the light was so dim. The exposure was as long as a quarter of a second with the lens open to allow in all the light possible. At that speed you can still anticipate the small pause there is in almost every human gesture, but you miss a lot of them (at half a second you miss them all). On this sunny day in Paris beside a large window, the light was bright enough to use a fifteenth of a second and stop the lens halfway down to keep the background identifiable. Of course, Mrs. Lartigue still blurs, but we catch the spirit of her action.

If they had remained serious, sitting straight up, I would have arranged Mrs. Lartigue's head to conceal the light fixture in the next room and Mr. Lartigue's to hide the little painting on the wall. I would fit them into the architecture of the room correctly. But when they laugh, the action holds our interest enough to override the architectural mismatching. Her gesture—the hand on his chin, head nestled in his cheek—is very tender. Their matching blouses bring them together and help separate them from the myriad objects in the room. It did not take long. "He wants to say that he thinks you are a real professional," Miss Fayard told me as we left.

JACQUES-HENRI LARTIGUE, 1981

Most portraits show someone sitting in a chair looking at the camera. When I was photographing Jacques-Henri Lartigue earlier in the week as he sat in his chair in his apartment and looked toward the camera, it occured to me to ask if his boyhood home still existed. It did, a few blocks away. We made arrangements with the owner who welcomed Mr. Lartigue as a national treasure. I was looking for a portrait in action.

Lartigue had taken a picture of his cousin leaping off these same steps, her full skirt flying, in 1905. He was nine. Six years later, he photographed a young man sitting fully clothed in an inner tube in the water. I wasn't interested in recreating these photographs, because I couldn't. Mr. Lartigue was limber, but not as limber as his cousin had been seventy-six years before. and I had asked for inner tubes, thinking of the large American cars that I grew up with. What came were modern, mini, French ones, just right for an eighty-five-year-old man to toss up and down. We fetched them when he missed the catch.

Amidst the tossing, I made a mistake. In one exposure where his expression is right, the tubes are right and his arm is right, I just, just cut off his foot. Usually I think if there is something imperfect in a photograph it makes the picture more real. Photographs that are slick, smooth, and perfect seem less honest to me. On the other hand, sometimes the imperfection is just annoying, like this one. I have been tempted to cheat and ask a retoucher to put his foot back in—just to see how it looked. Of course, I'd probably think it was too slick, too smooth, too perfect. I wouldn't be surprised if the ancient Greeks had a word for this kind of agony.

INDEX